COLOR SOURCEBOOK

A COMPLETE GUIDE TO USING COLOR IN PATTERNS

Rockport Publishers * Rockport, Massachusetts Distributed by North Light Books Cincinnati, Ohio Copyright©1989 by Rockport Publishers, Inc.

All rights reserved. No part of this work may be reproduced in any form without written permission of the publisher.

First published in the United States of America by: Rockport Publishers, Inc. P.O. Box 396 5 Smith Street Rockport, Massachusetts 01966 Telephone: (508) 546-9590 Telex: 5106019284 Fax: (508) 546-7141 ISBN: 0-935603-28-X

Distributed in the U.S. and Canada by: North Light Books, an Imprint of F & W Publications 1507 Dana Avenue Cincinnati, Ohio 45207 Telephone: 1-800-289-0963 Fax: (513) 531-4744

CONTENTS

ETHNIC COLORS

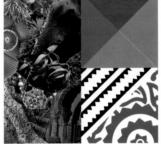

JAPANESQUE COLORS

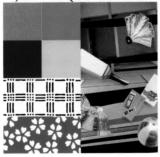

NATURAL COLORS

Image criterion & pattern table	6
Color bands showing coordination of basic	
colors and their	
applications to patterns	
(No. 1-160)	8

ORIENTAL COLORS

Image criterion & pattern table	40
Color bands showing coordination of basic	
colors and their	
applications to patterns (No. 161-320)	42

HIGH-TECH COLORS

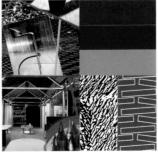

HIGH-TECH COLORS

Image criterion & pattern table	74
Color bands showing coordination of basic colors and their	
applications to patterns (No. 321-480)	76

PREFACE

COLOR SOURCEBOOK is a comprehensive guide to color coordination and balance in pattern, providing a practical insight into the nature and application of color combination. Because color is such an intimate part of everyday life, we never think twice about describing colors as being "somber", "festive", "cold", "cozy", or even "crazy". What this means is that no color exists for us in isolation. Without a frame of reference, usually other related colors, any color is essentially meaningless.

This manual is based on the concept that color harmonies and discords are culturally directed, and that by thinking in terms of cultural criteria the designer can get a head start in effective color design. The color and pattern combinations are arranged here under the headings Natural, Oriental and High-tech, creating a framework for the designer to work within, a forum for the comparison and study of trends in color and pattern. The concepts developed in this book continue, in COLOR SOURCEBOOK II, with the color coordinations Pop, Retro-modern and Postmodern.

Applications to patterns—

Each page presents five examples of patterns which were developed using two or more of the color bars at the top of the page. By studying and experimenting with these patterns, you can see how any two or more colors work together to create different effects. The same coordinated set of colors can say vastly different things depending on how they are assembled and applied. Use these applications as a "casebook" to help you arrive at effective color schemes more quickly, accurately and creatively.

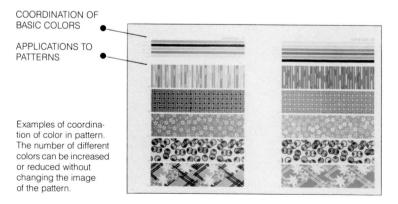

Ilmage Criterion

Natural: These color combinations derive from naturally available dyes and naturally colorful materials. The tones are more subtle than those found in an urban palette of bright, simple colors. Here is a gentle wealth of understated hues and regular patterns that can be used to create a natural, restful fabric, background or environment.

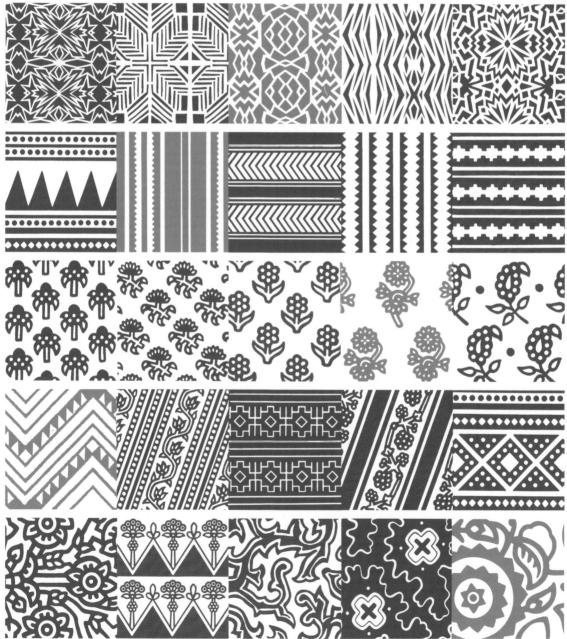

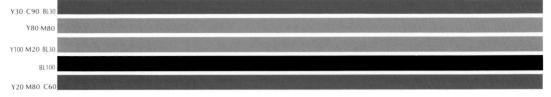

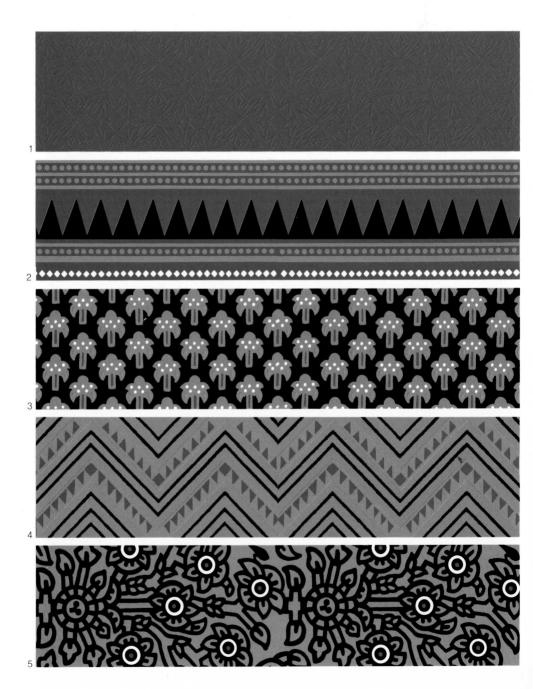

8

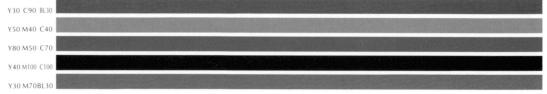

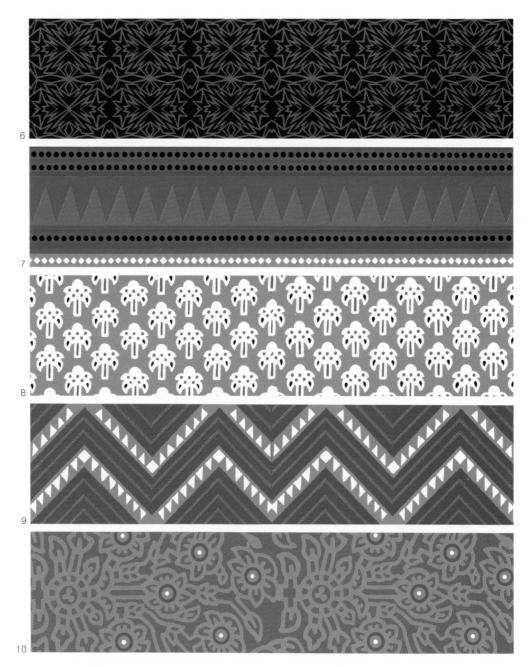

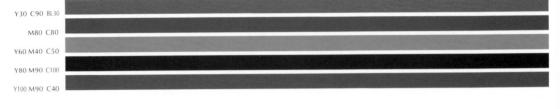

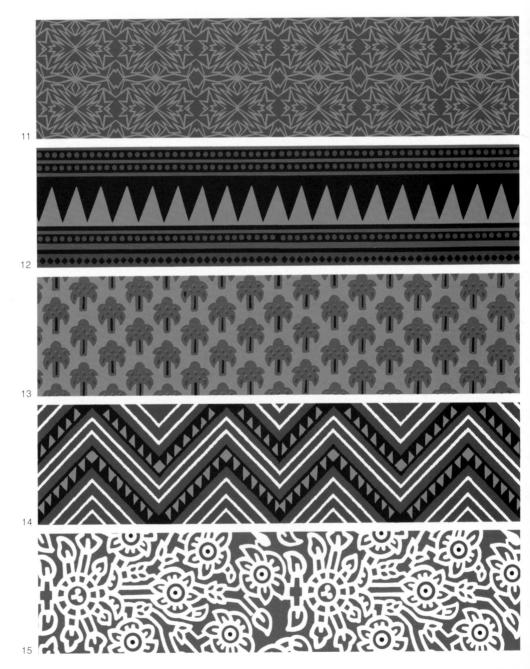

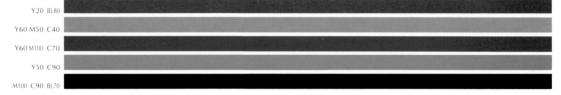

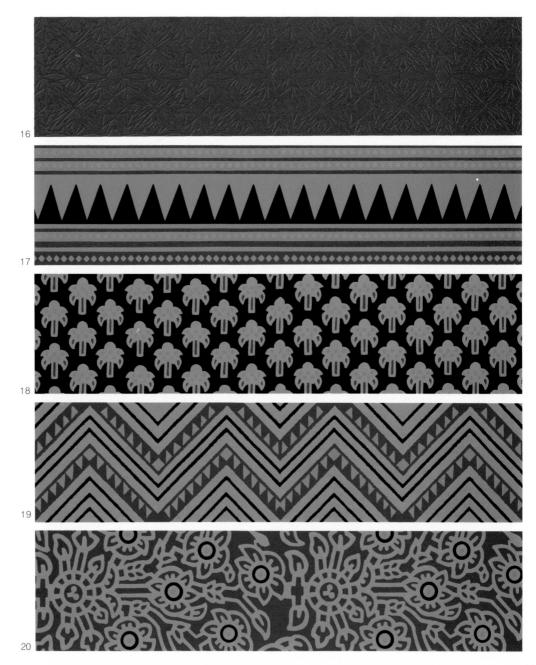

11

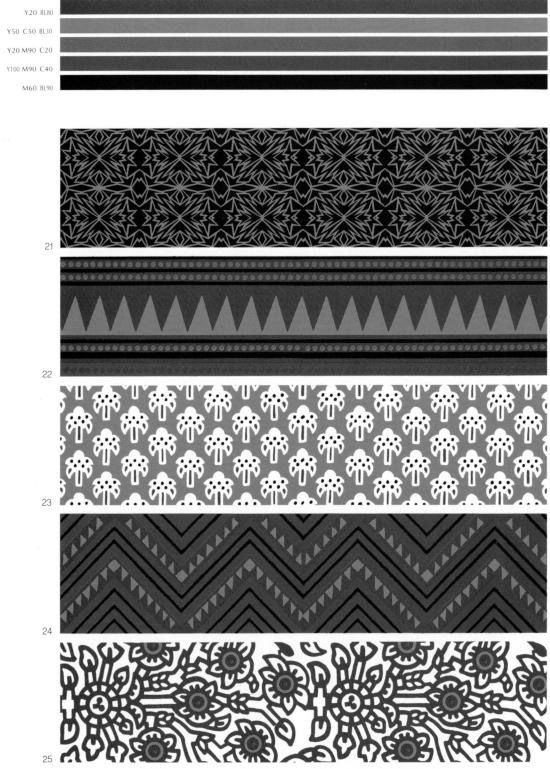

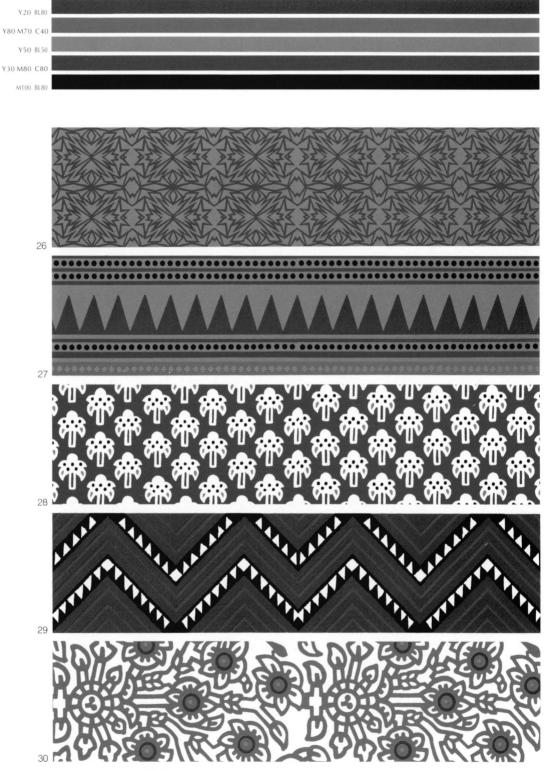

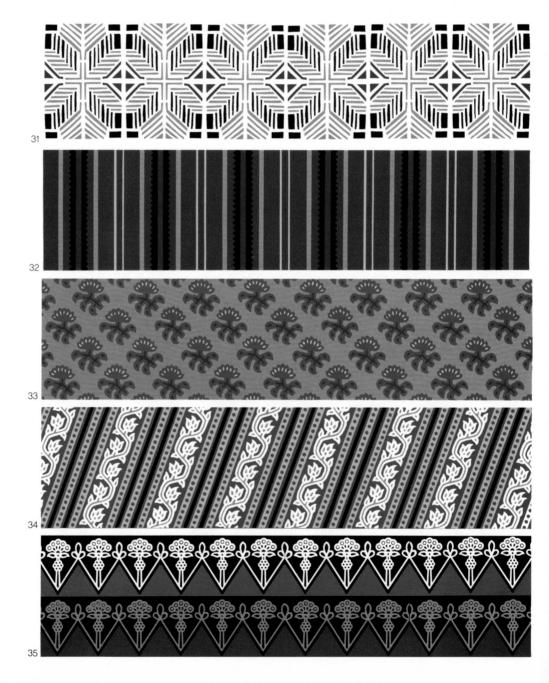

14

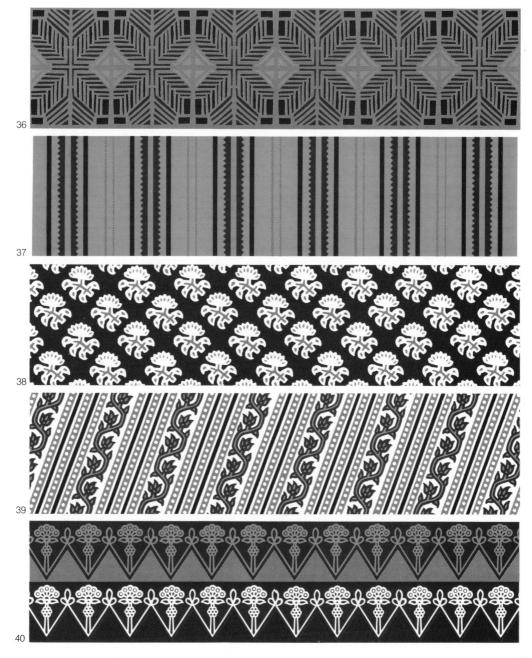

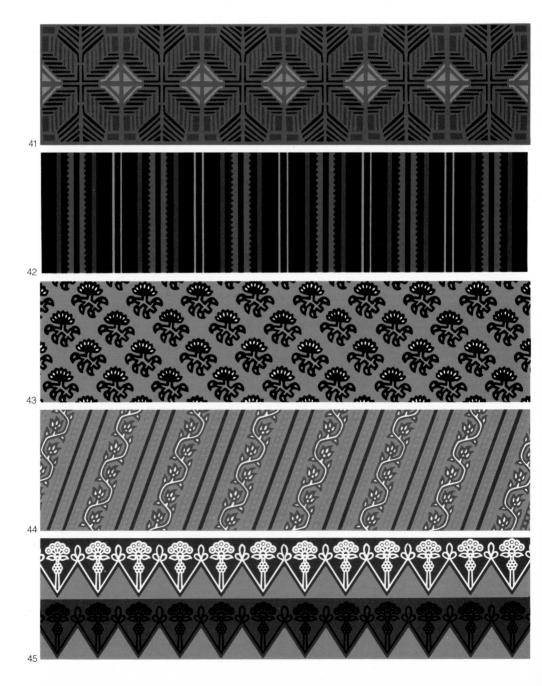

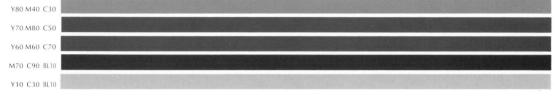

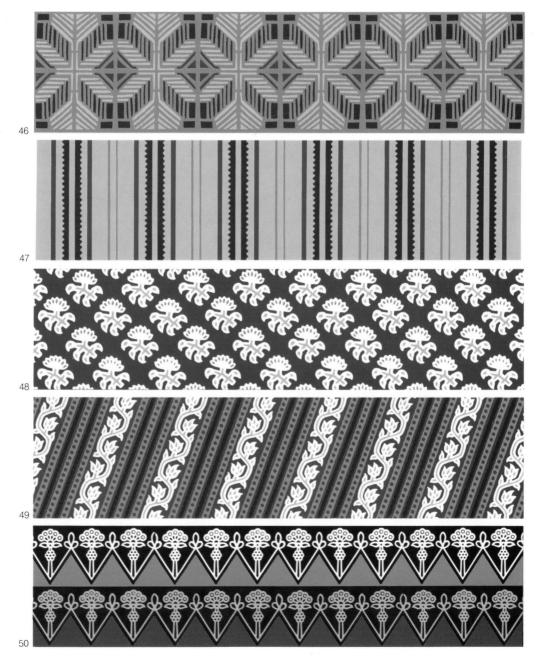

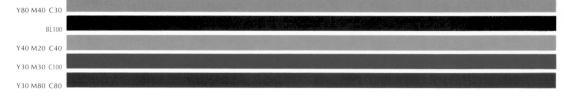

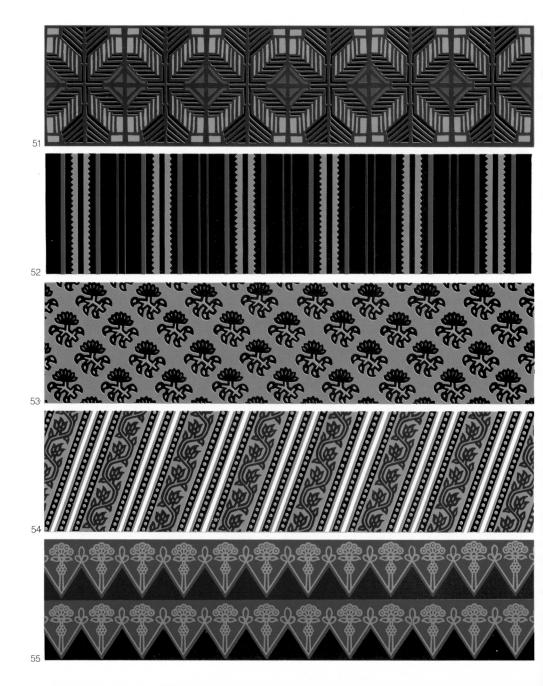

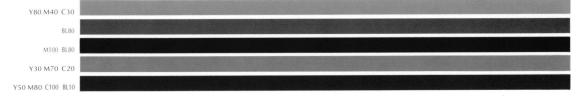

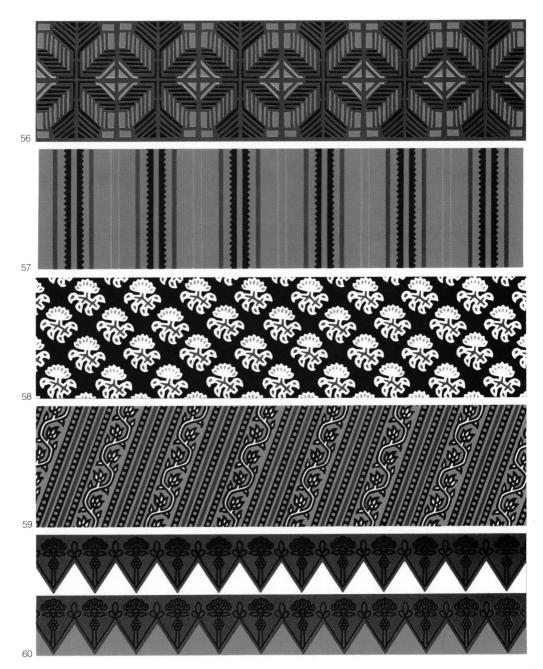

19

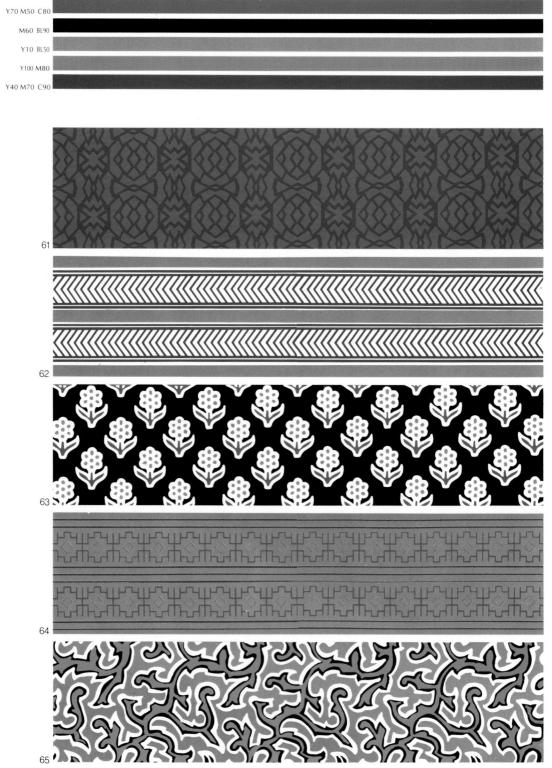

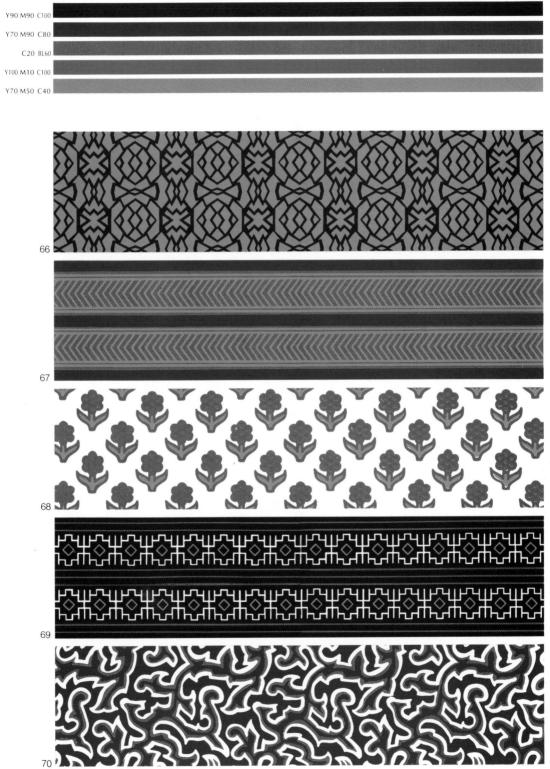

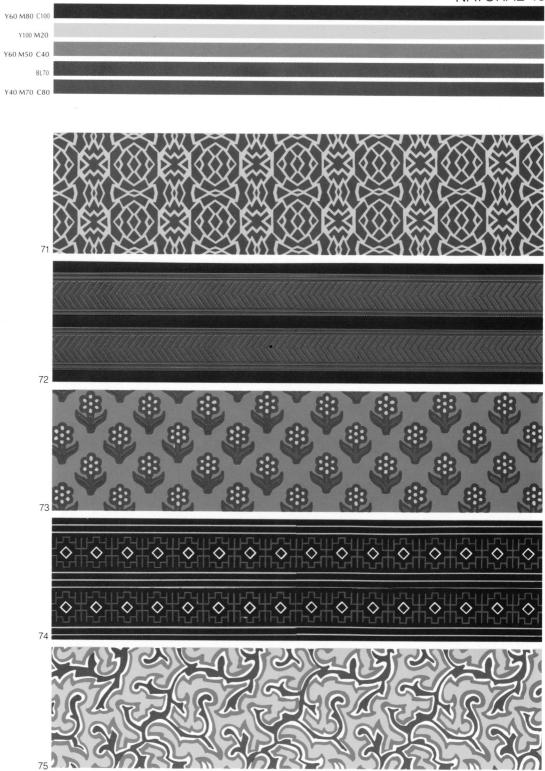

/

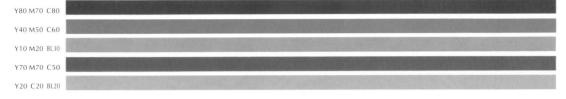

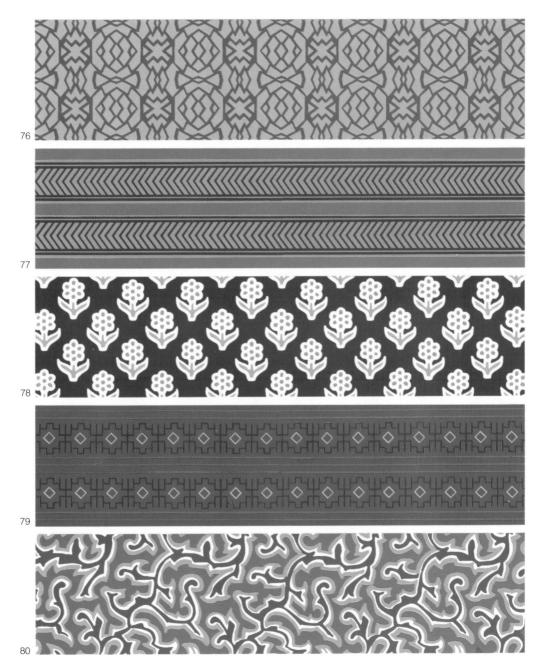

23

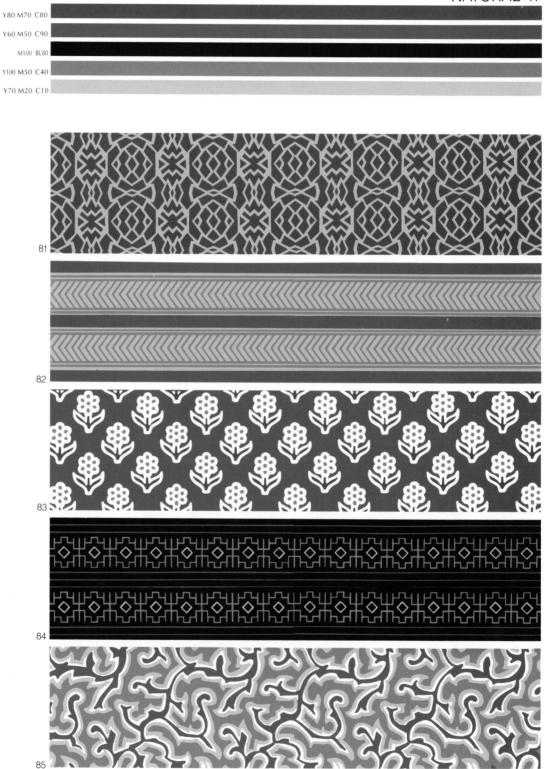

24

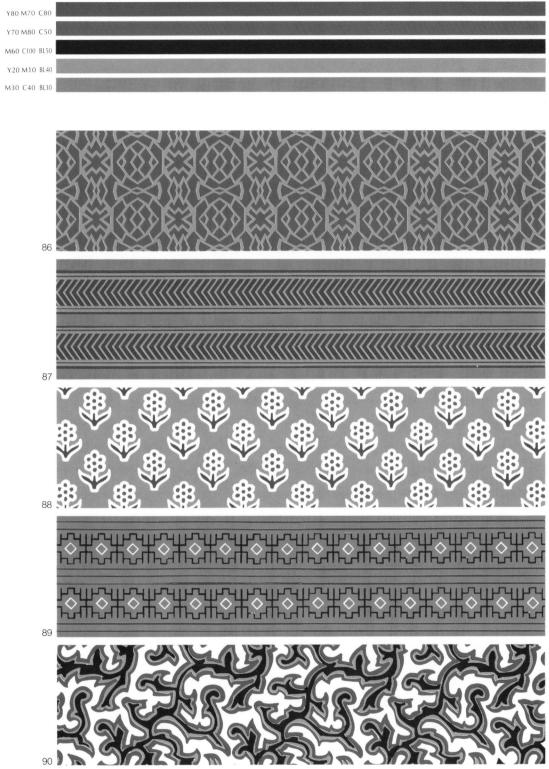

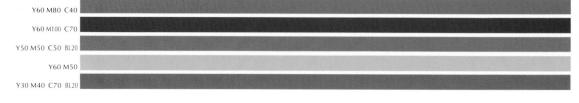

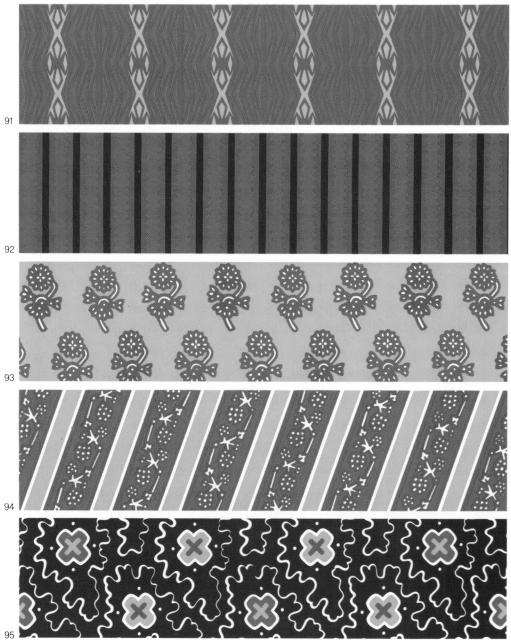

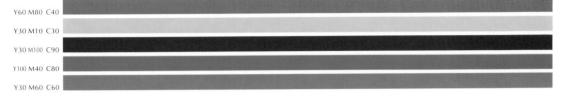

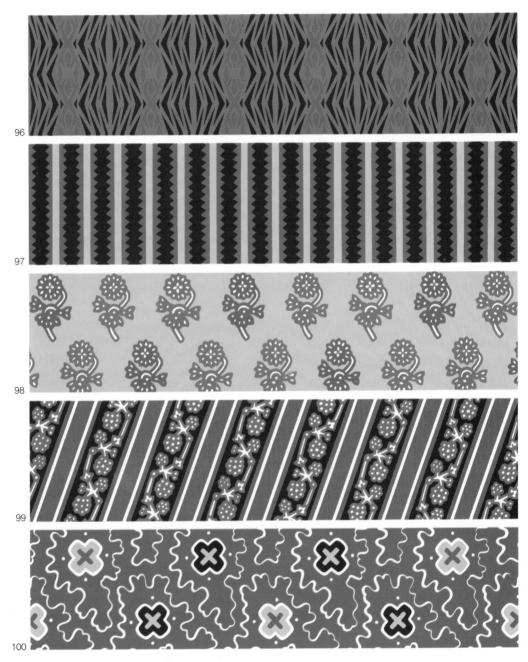

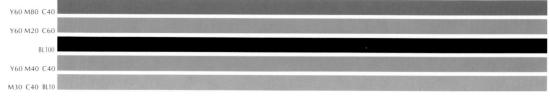

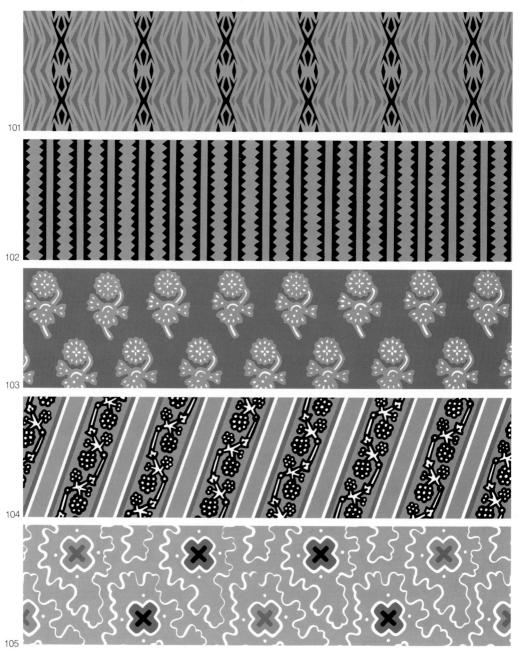

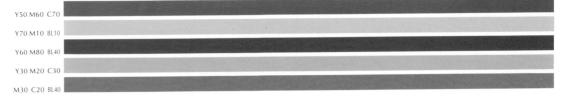

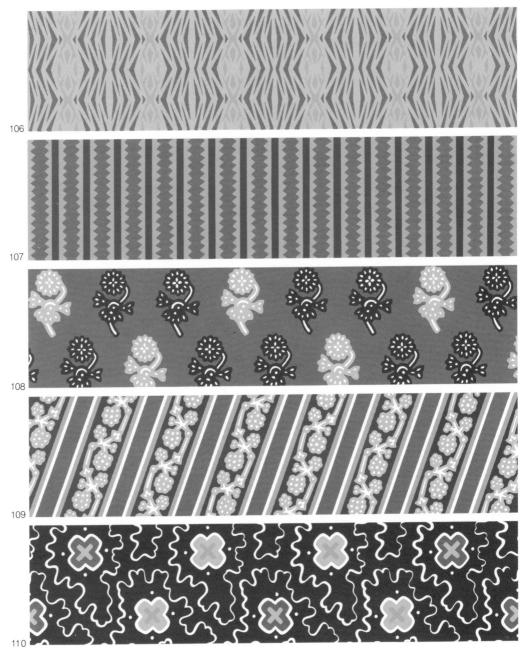

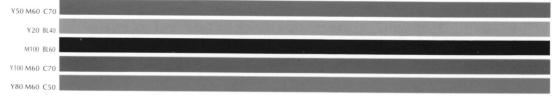

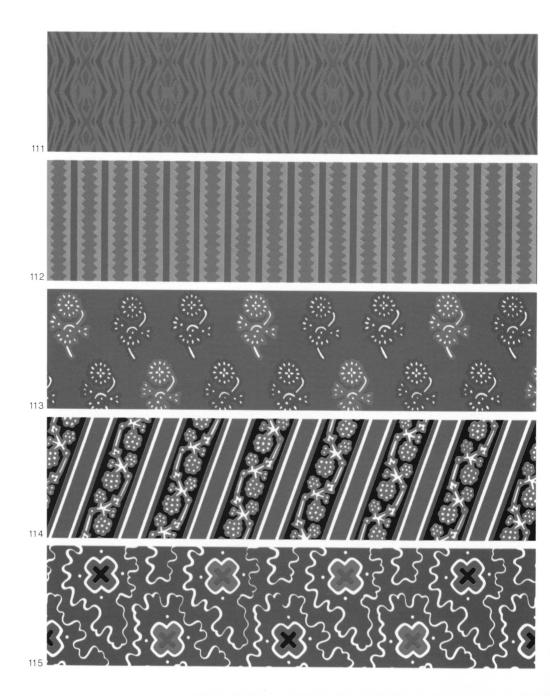

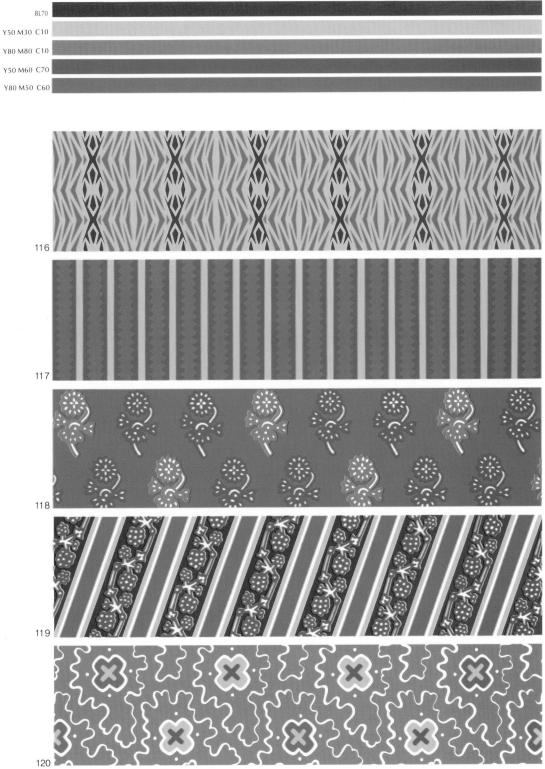

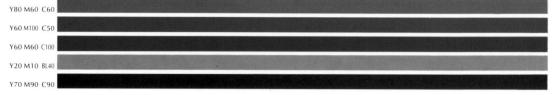

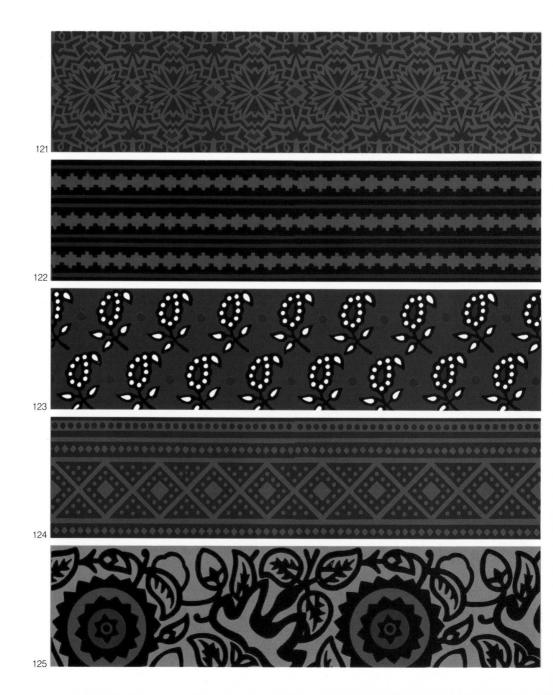

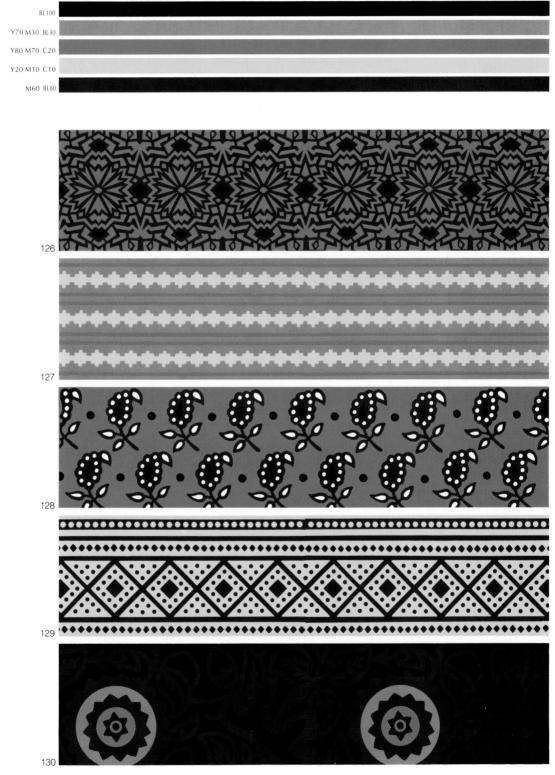

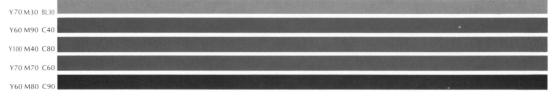

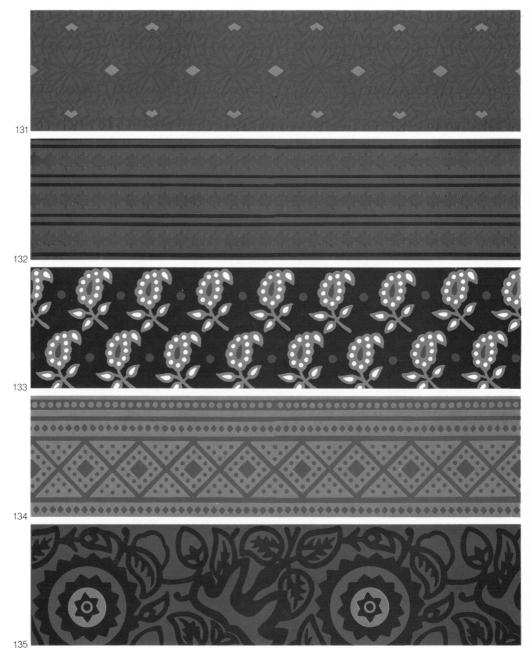

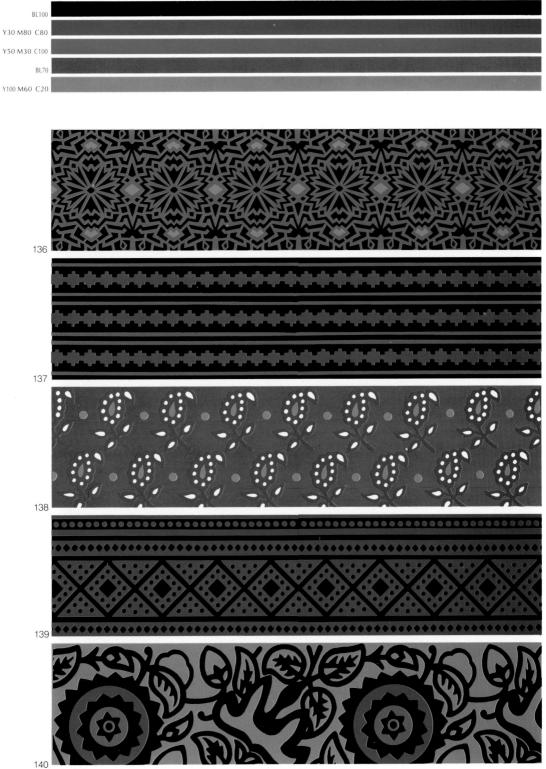

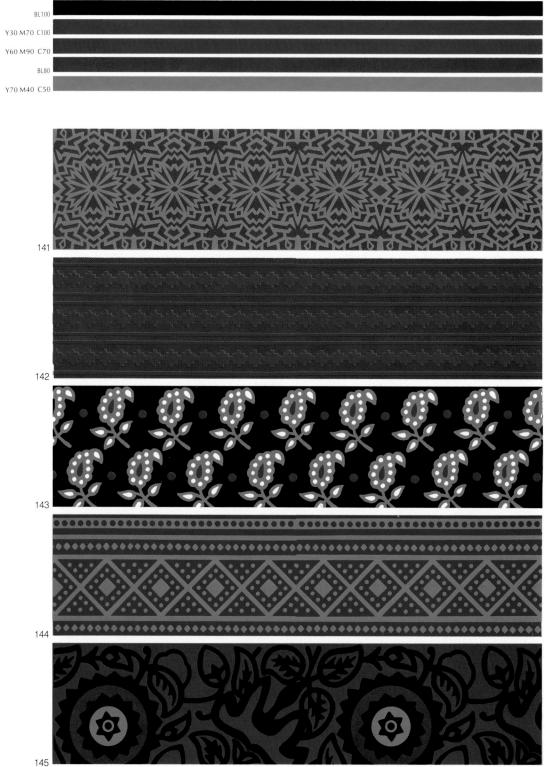

NATURAL 30

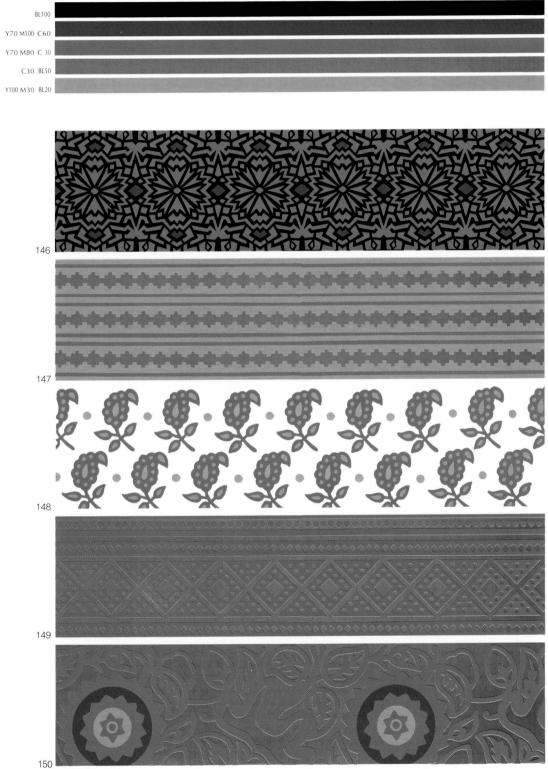

NATURAL 31

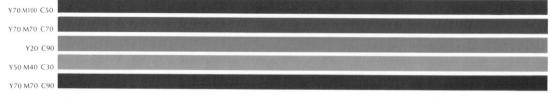

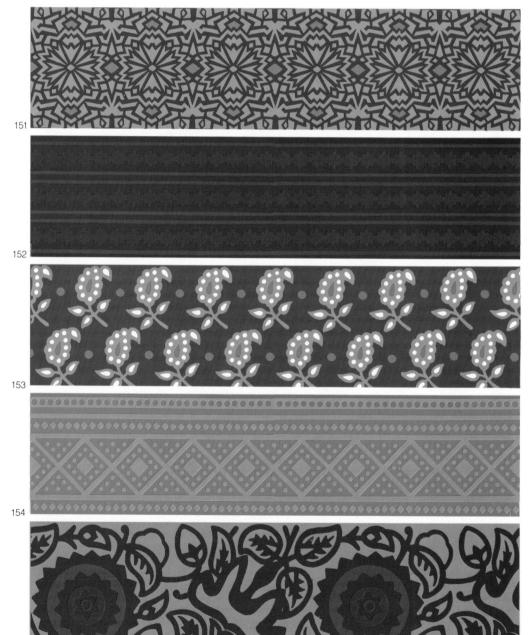

NATURAL 32

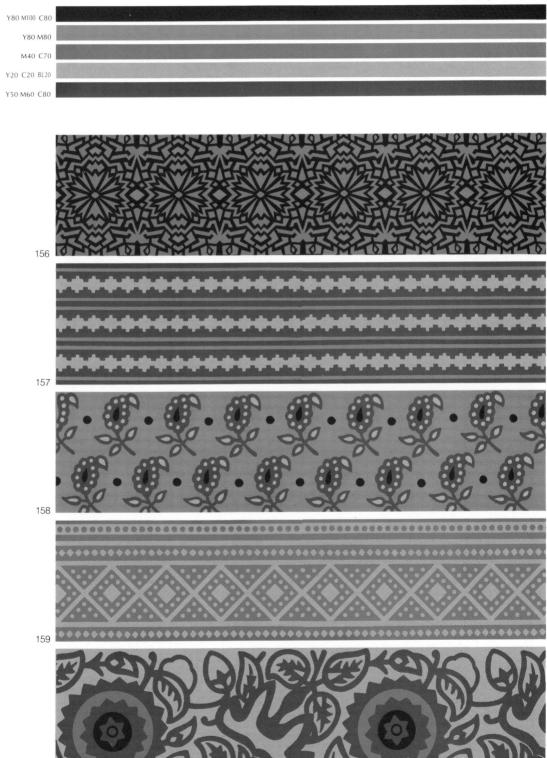

Image Criterion

Oriental: Intentionally reminiscent of rice paper, the open sea and sepia inks, these colors can visually enlarge a room or merge it with an outdoor view, flavor an image without imposing a "look", or allow an ensemble some maturity without robbing it of enthusiasm. Even at their brightest, these are very finely tuned colors.

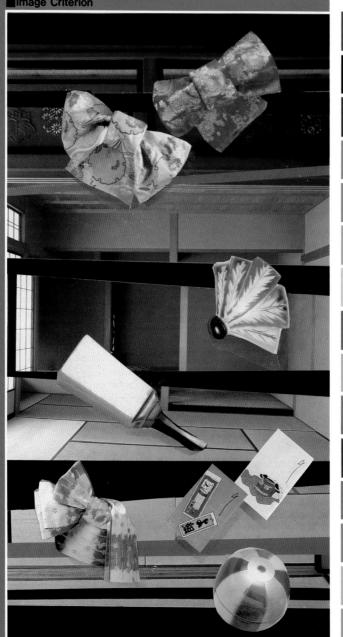

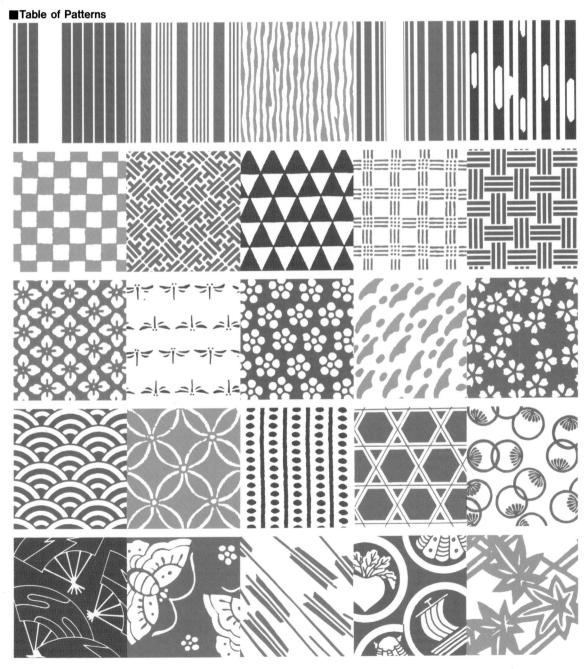

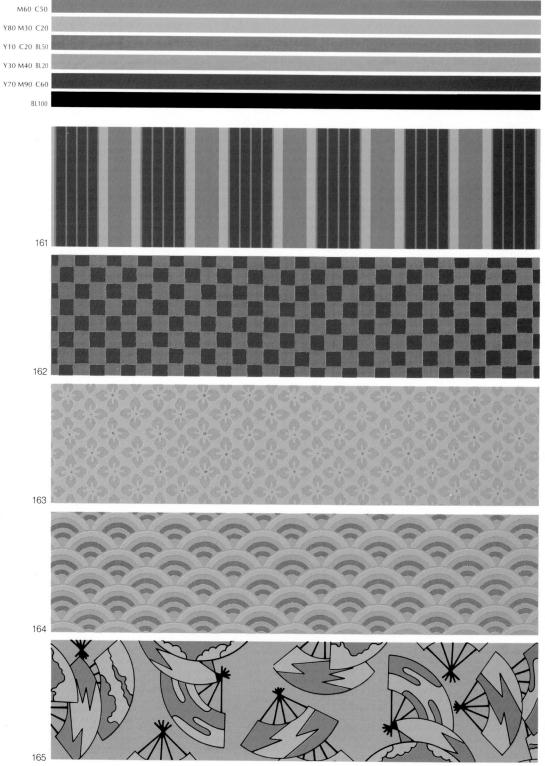

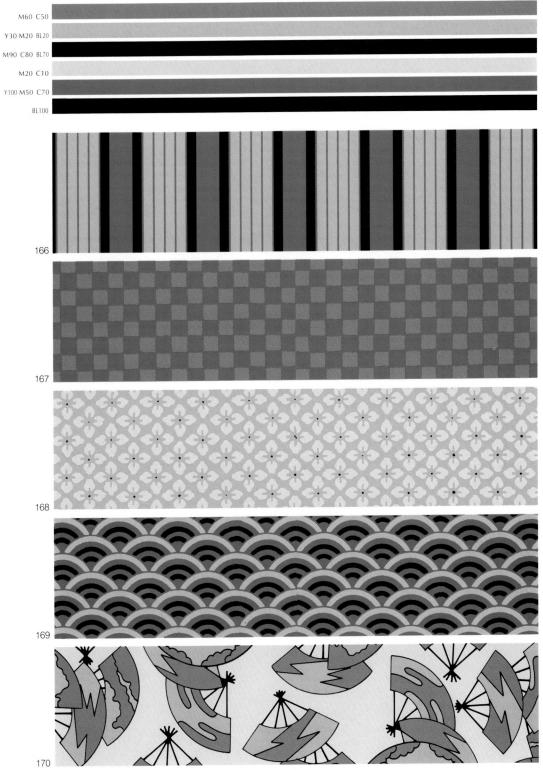

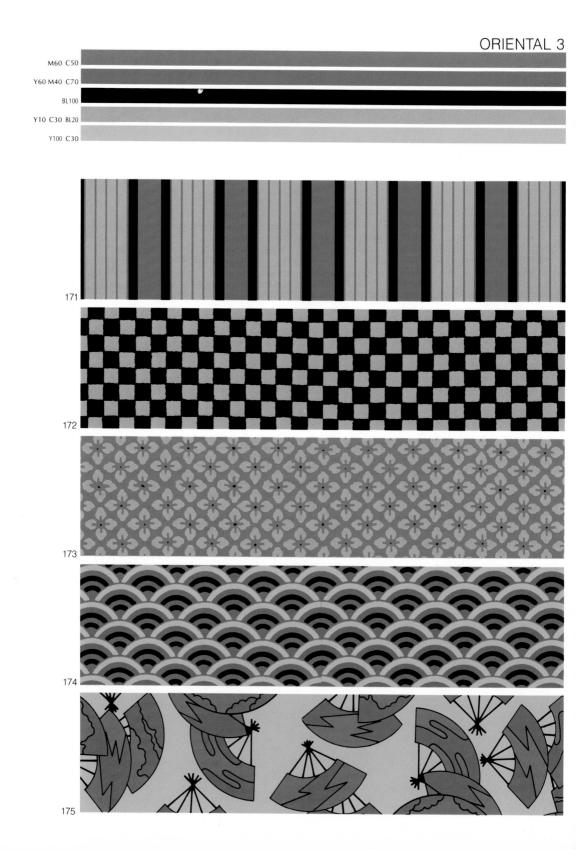

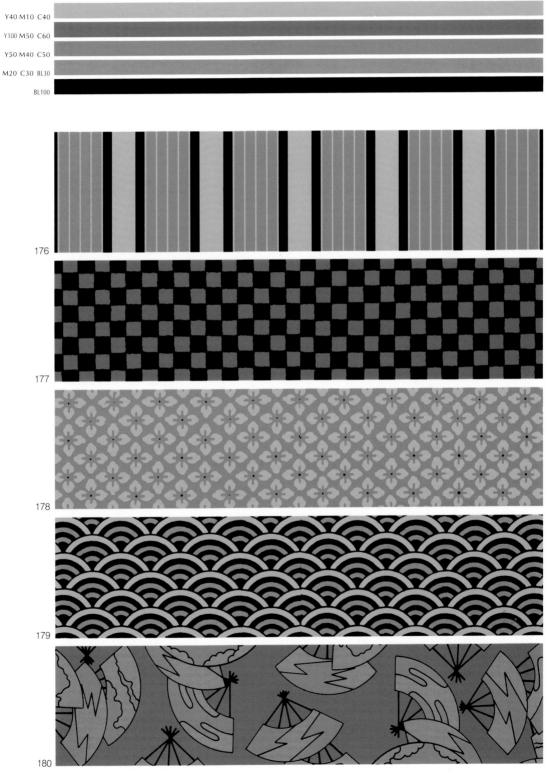

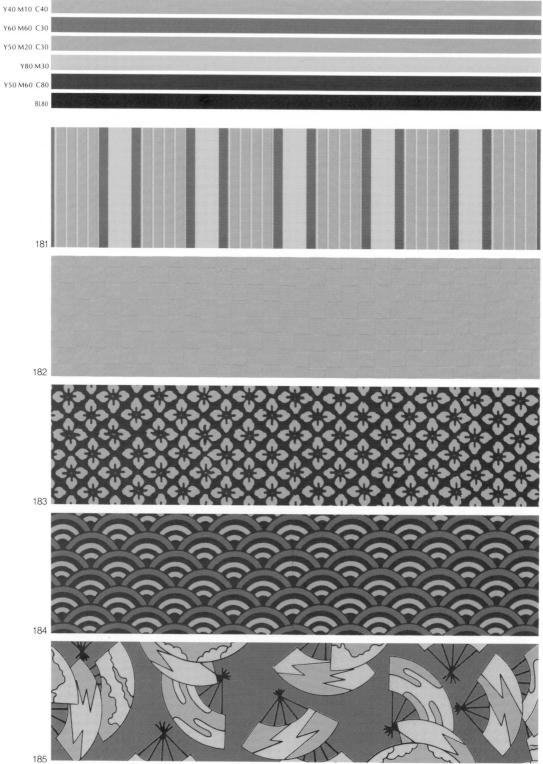

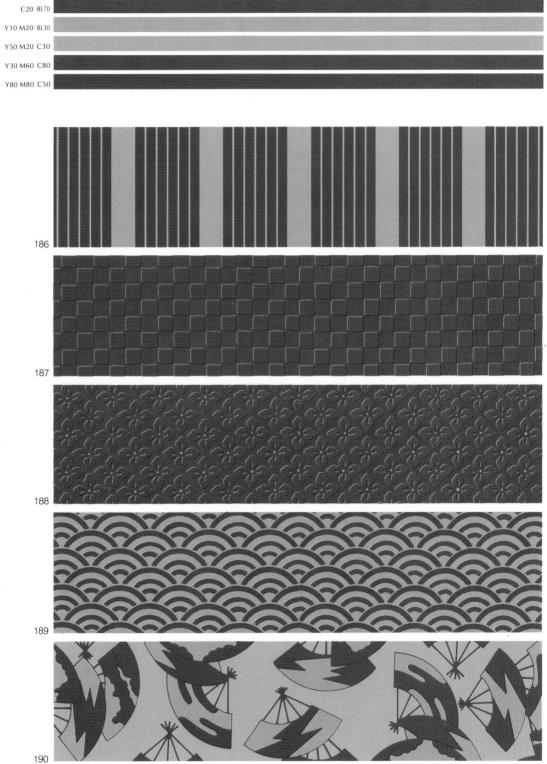

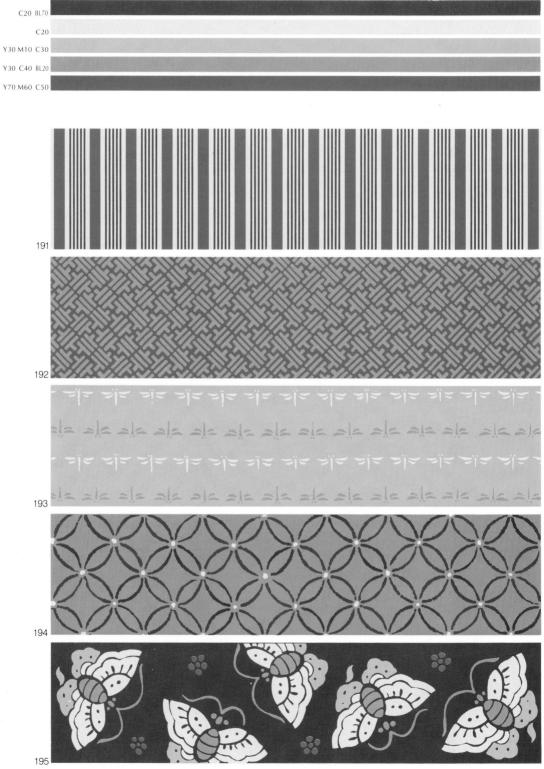

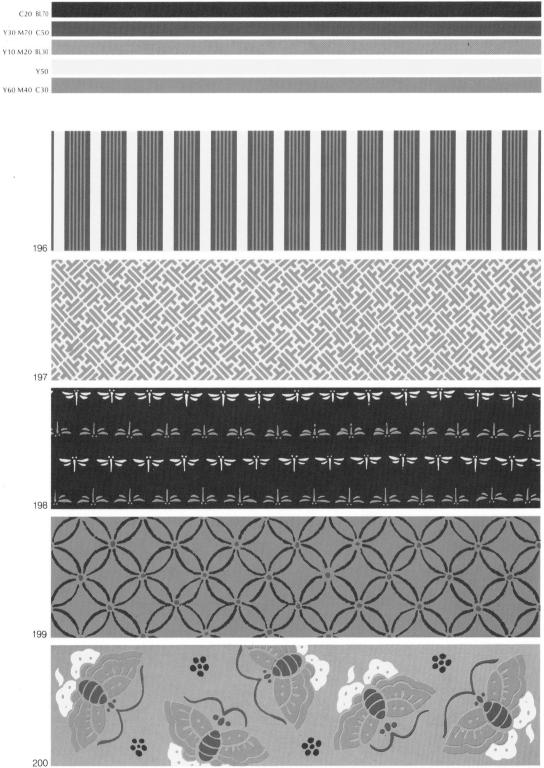

49

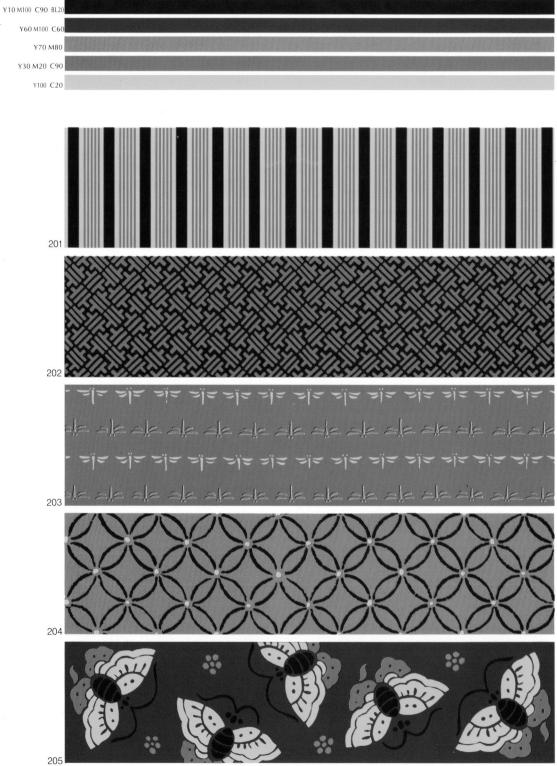

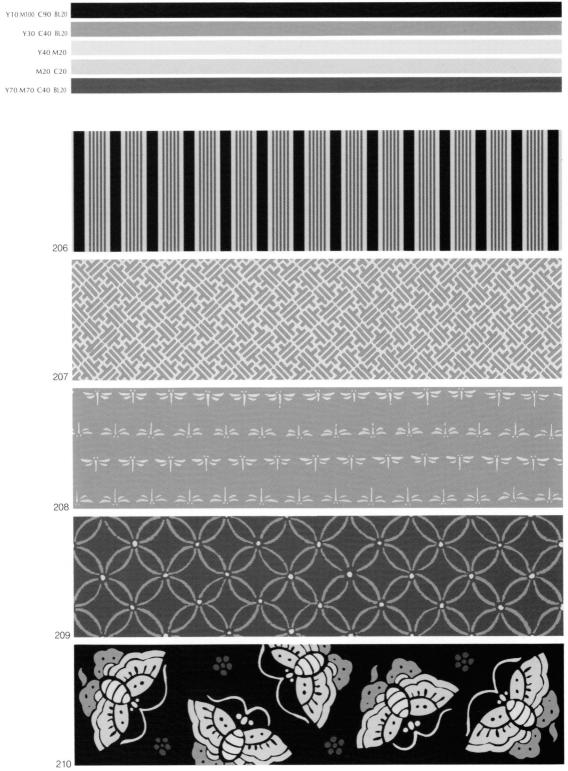

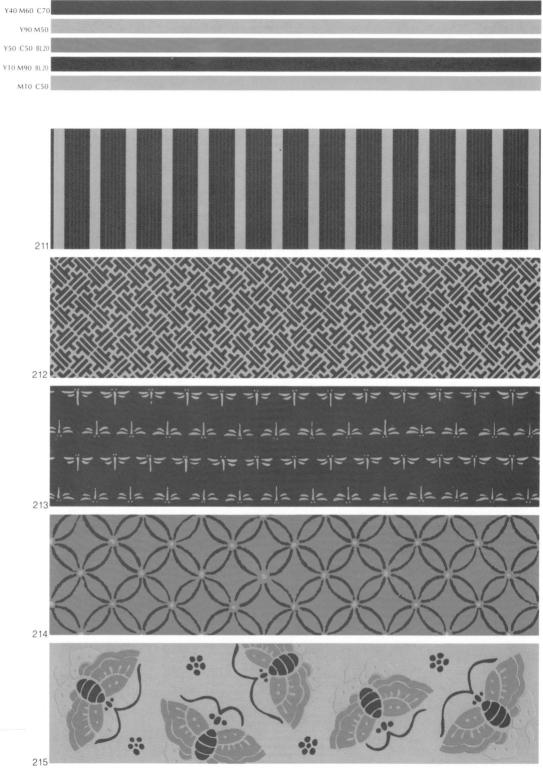

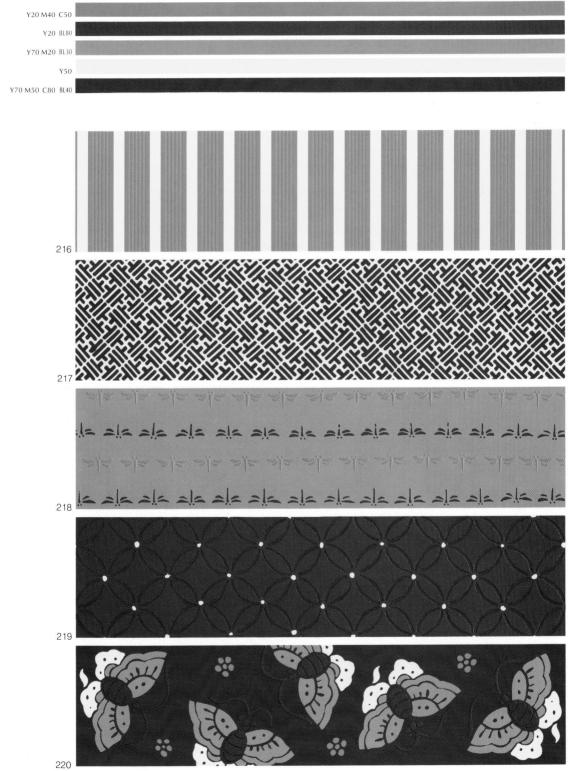

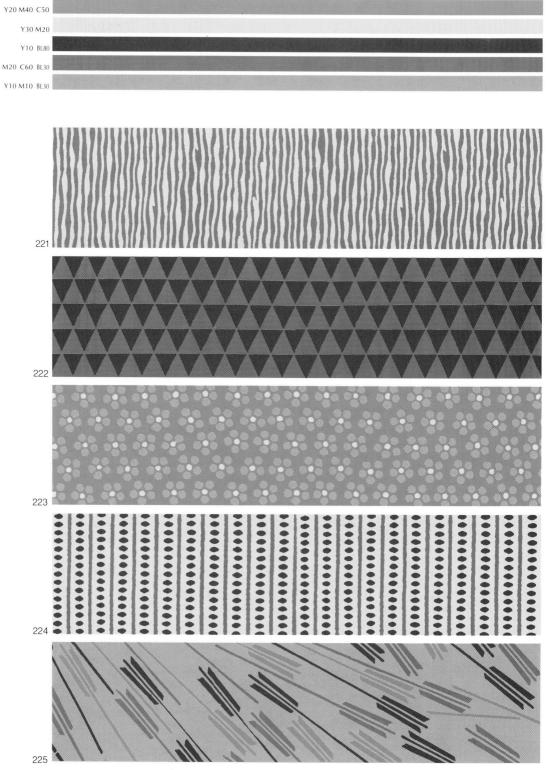

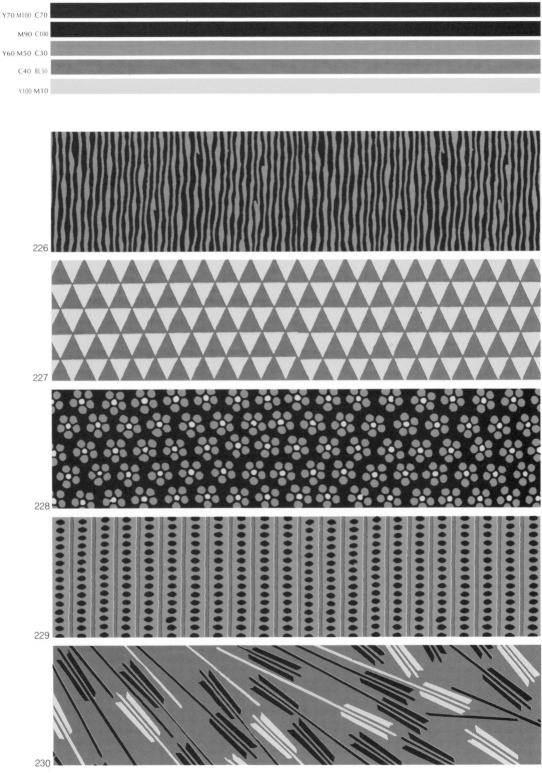

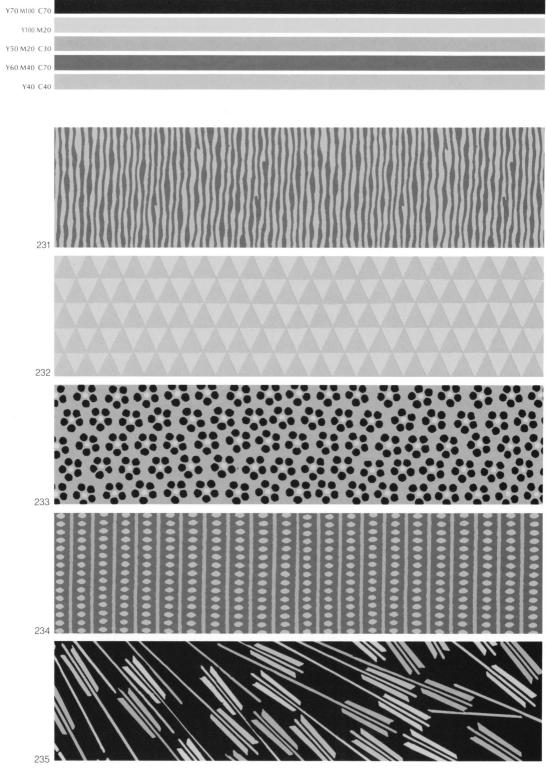

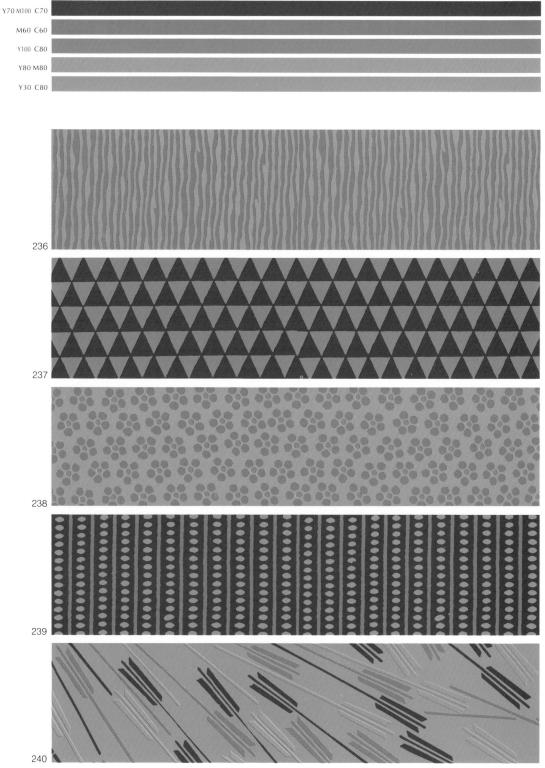

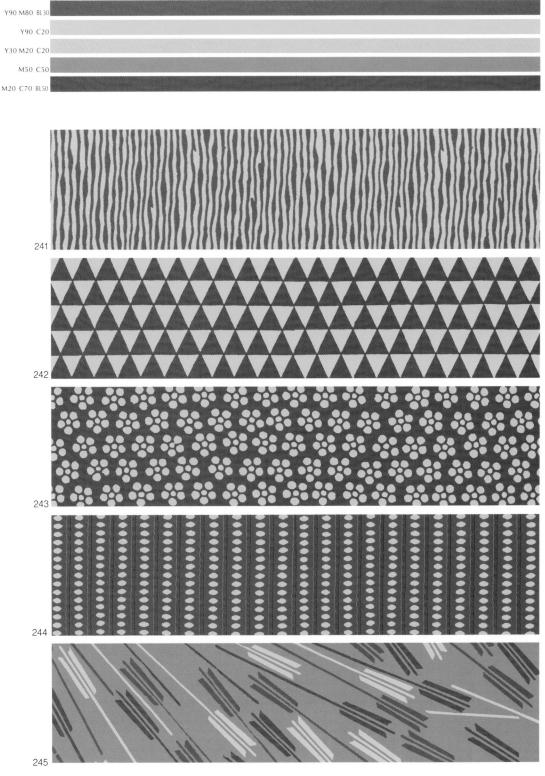

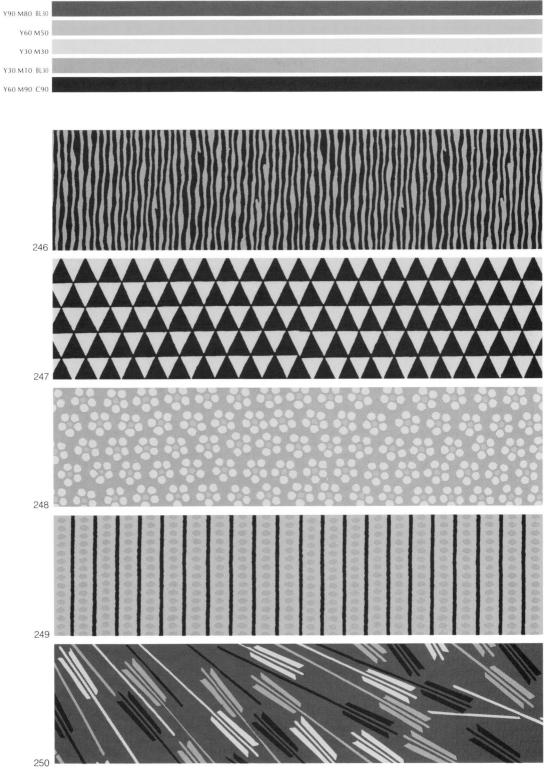

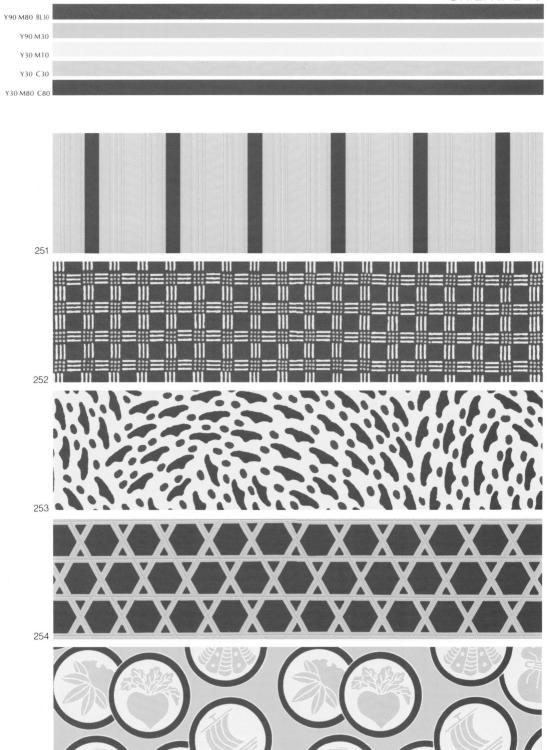

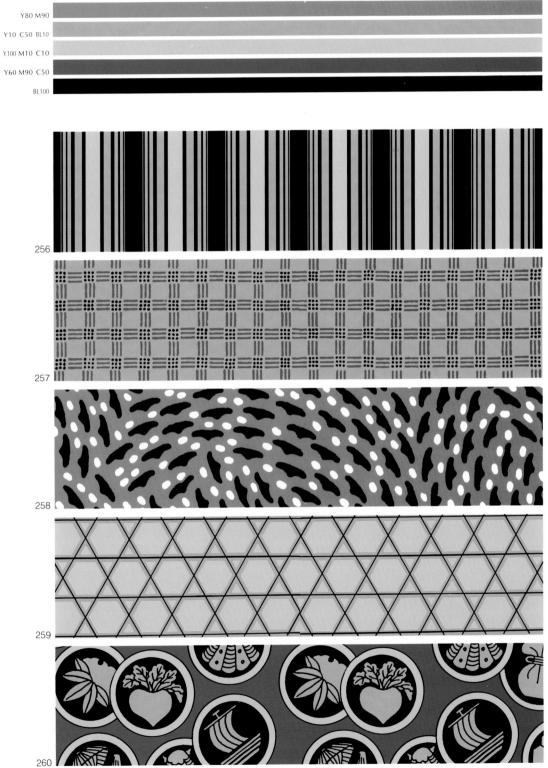

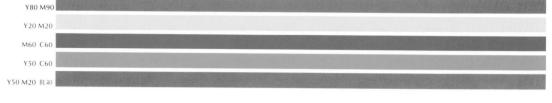

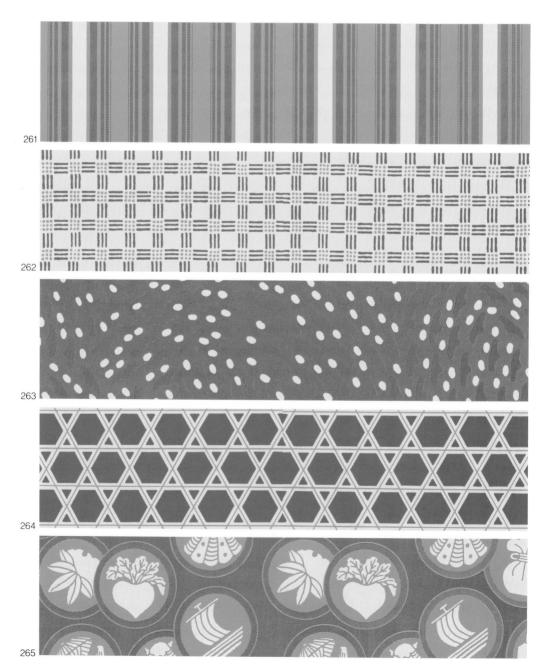

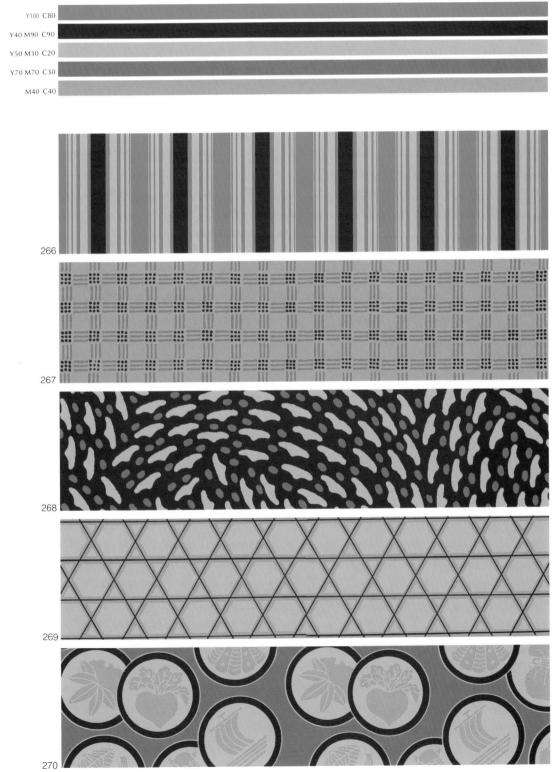

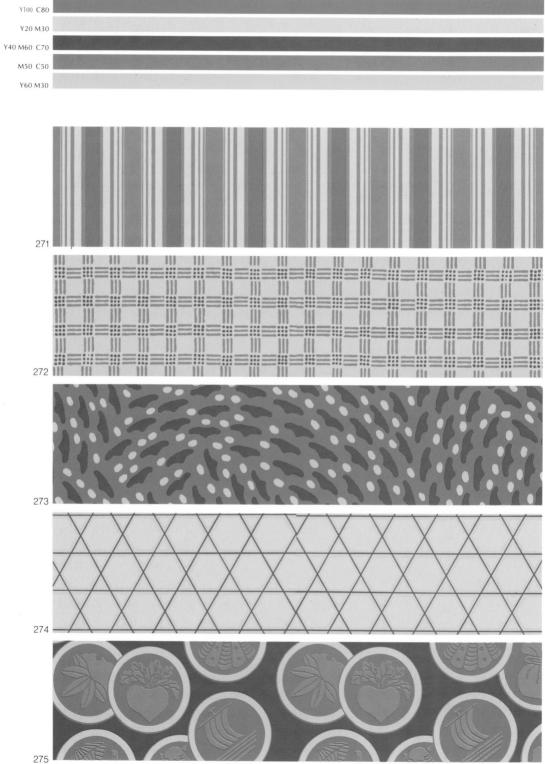

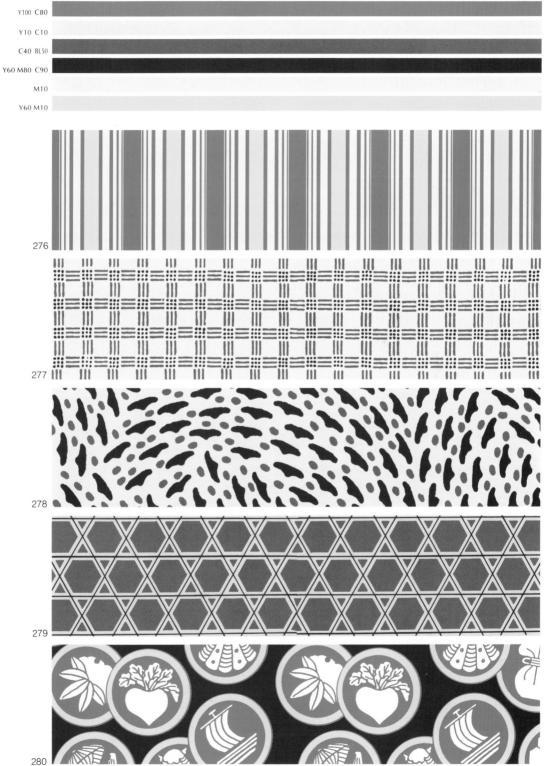

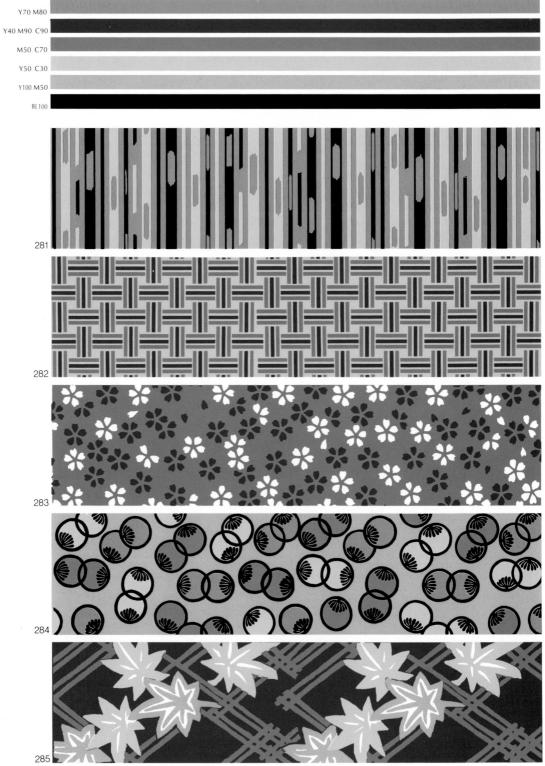

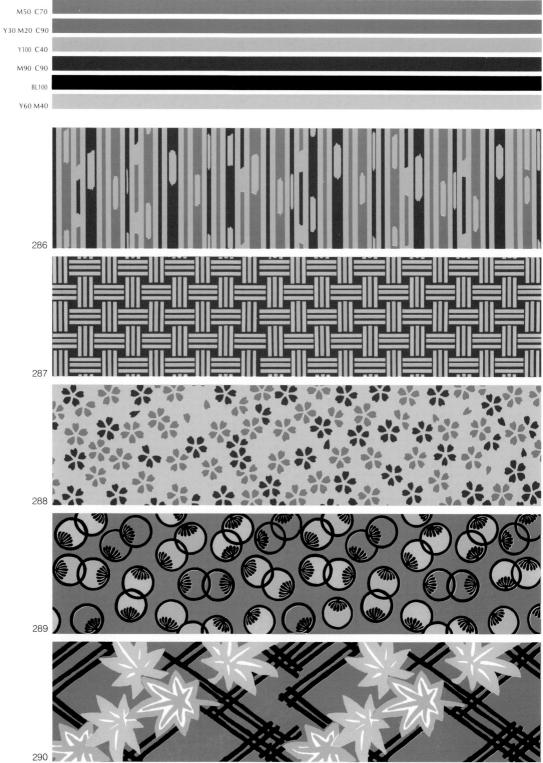

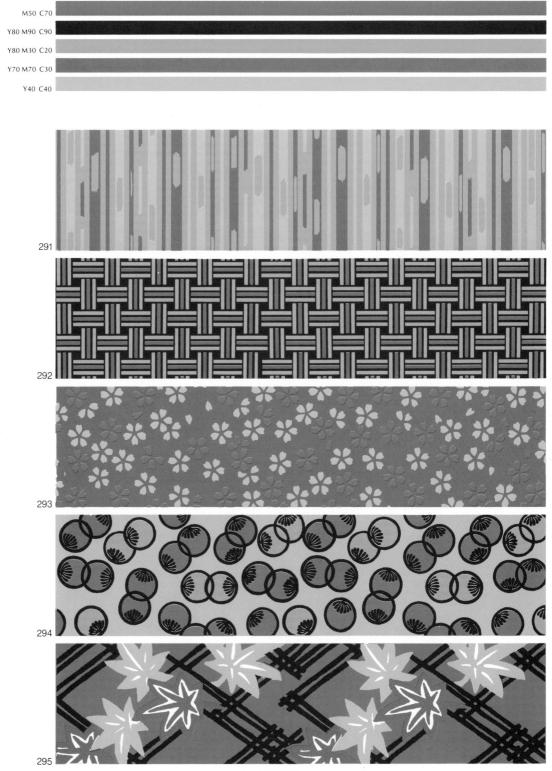

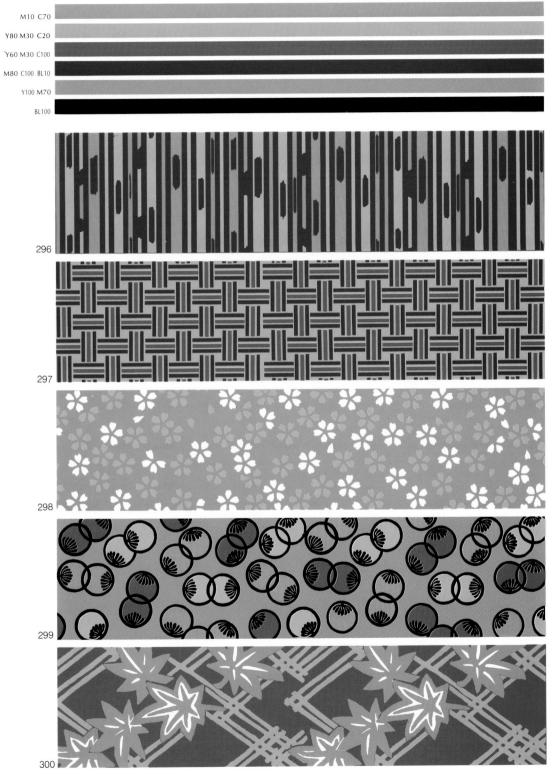

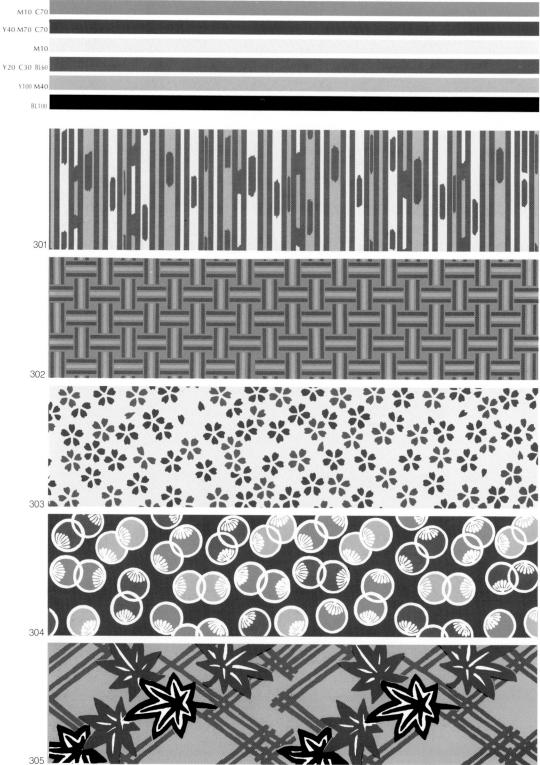

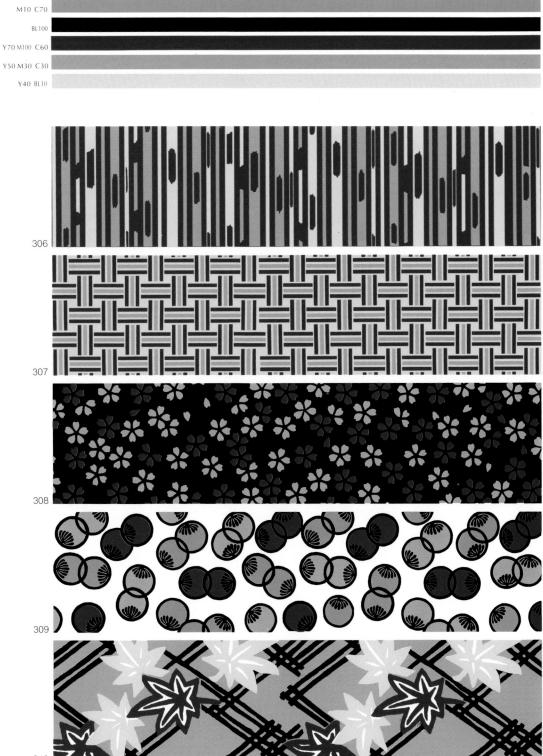

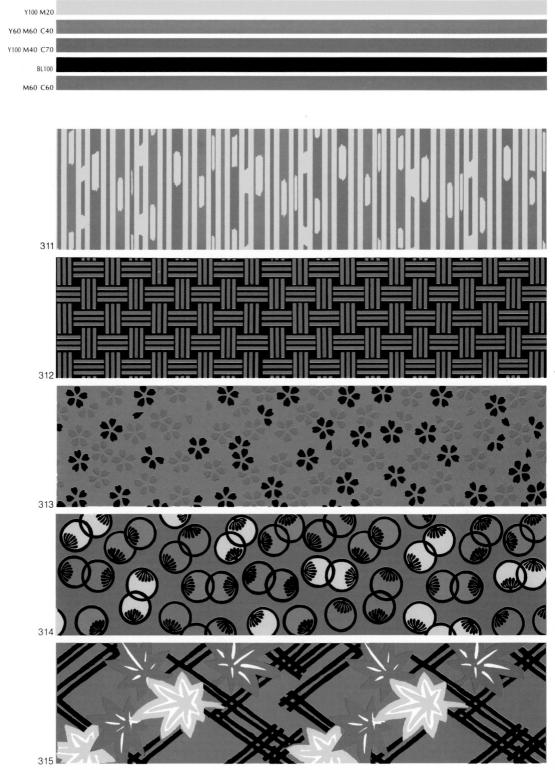

ORIENTAL 32

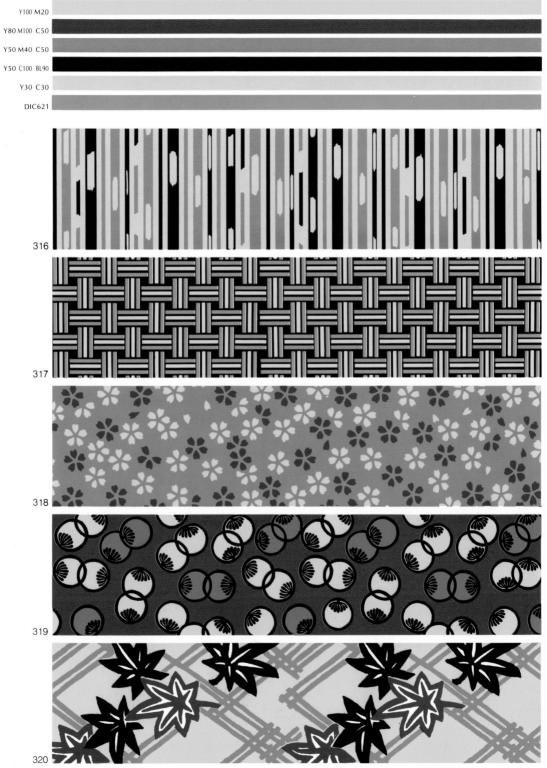

Image Criterion

High-Tech: Tending toward the cooler hues, this is a series based on the colors of woods, metals and glazes—the materials of architecture, intstruments and appliances. Application of many of these combinations with some of the crystalline patterns may render an interior or a garment cold or hard looking, but used properly can convey a clean, sophisticated, business-like feeling.

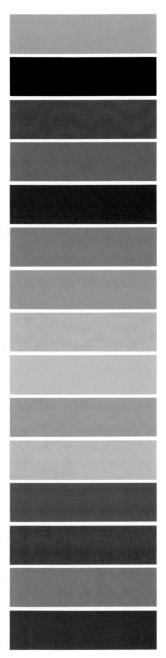

Table of Patterns

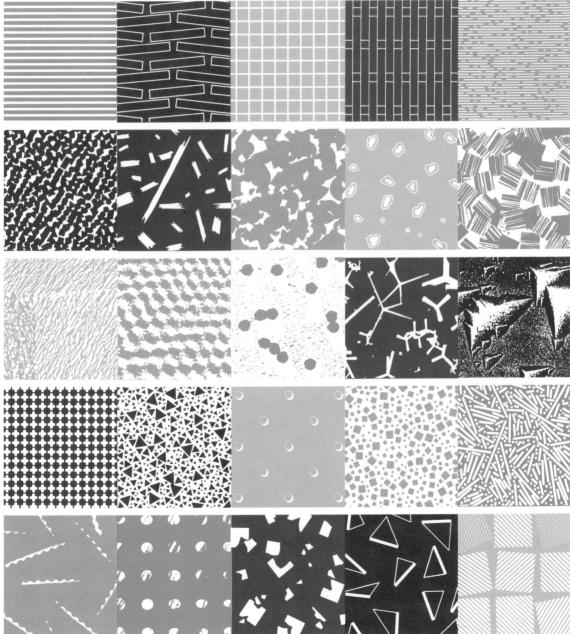

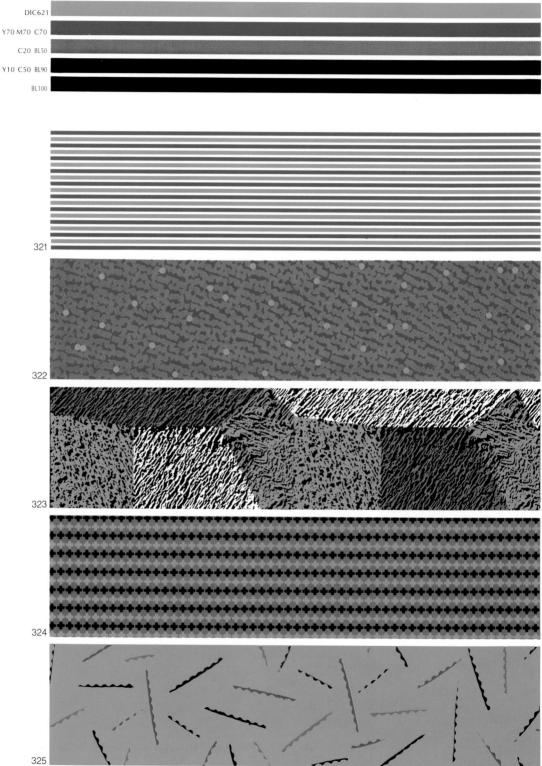

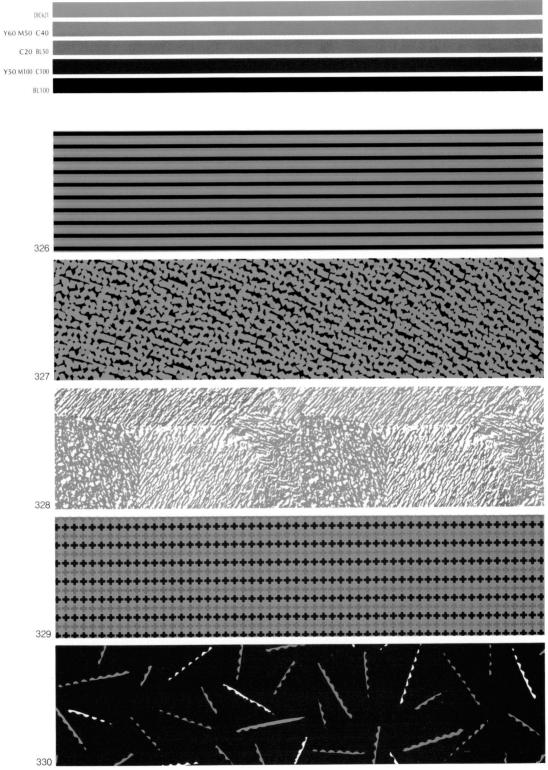

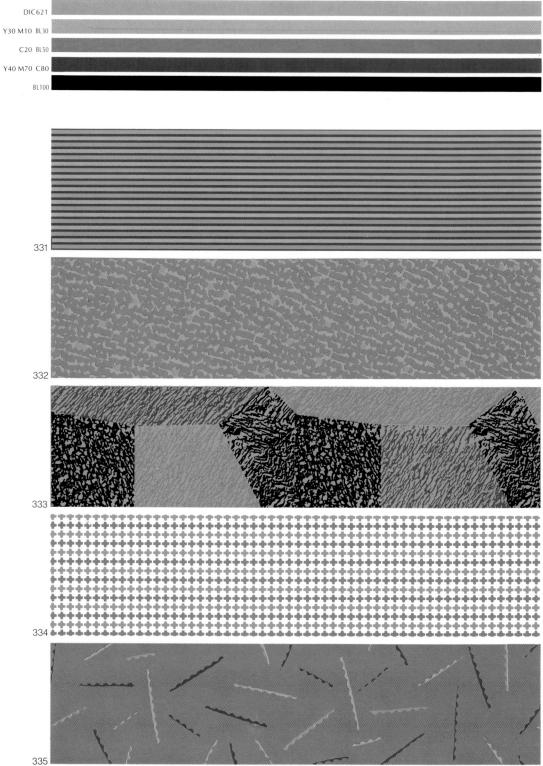

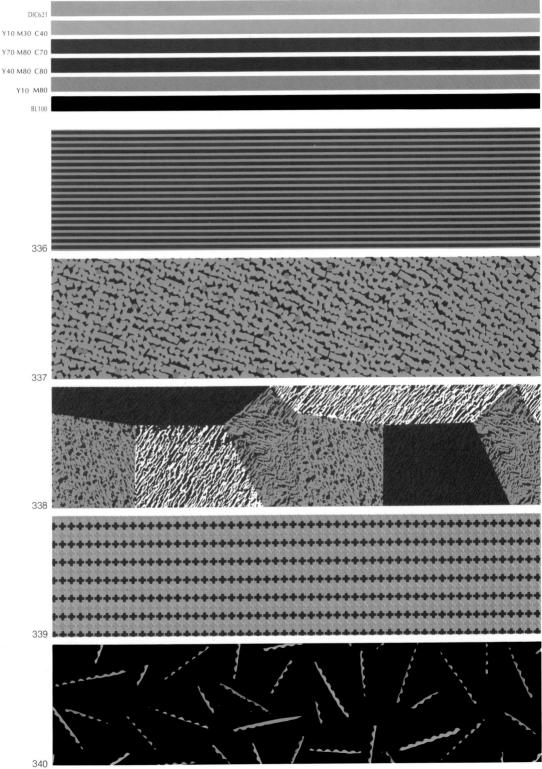

79

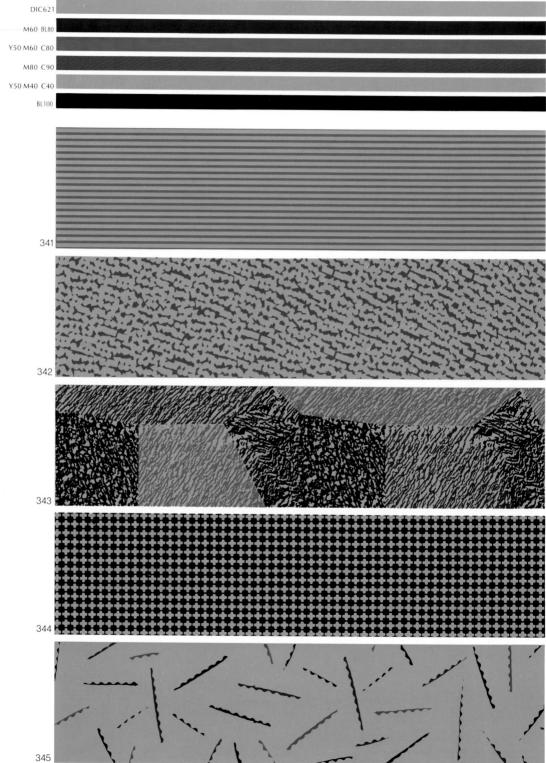

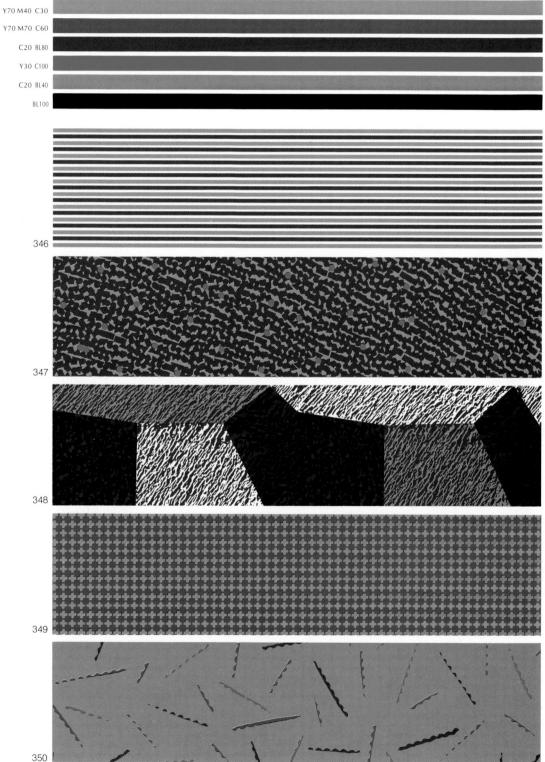

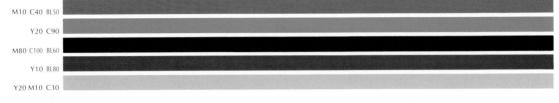

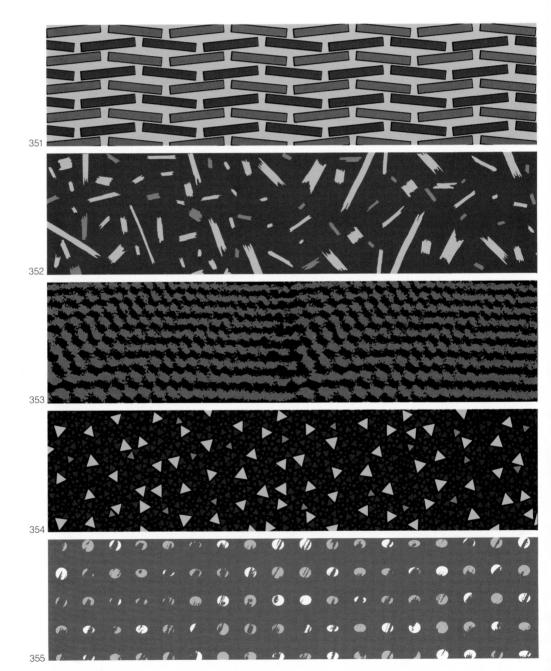

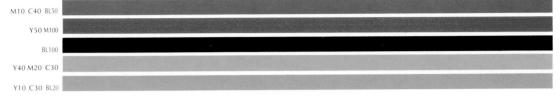

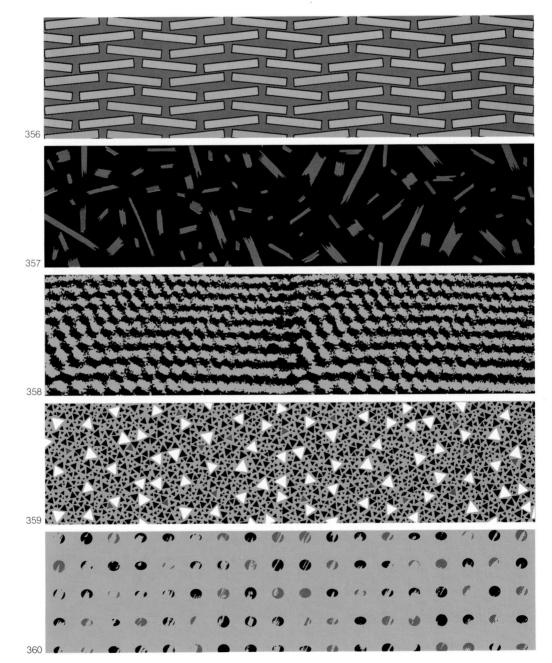

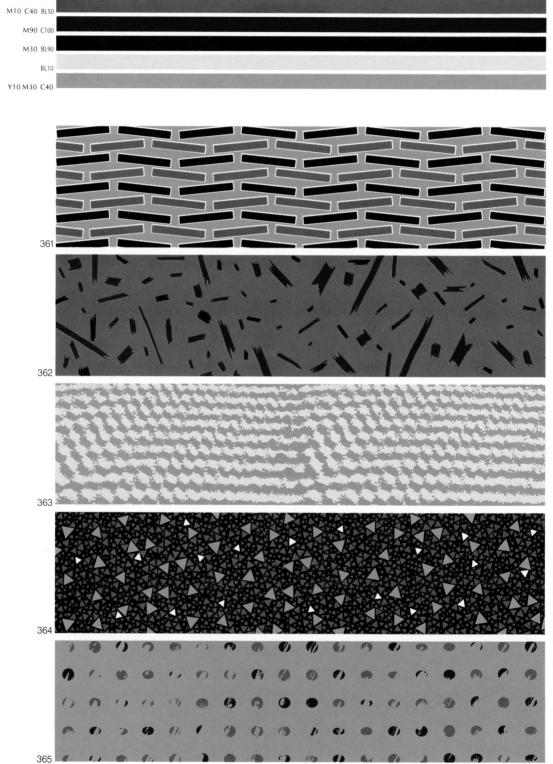

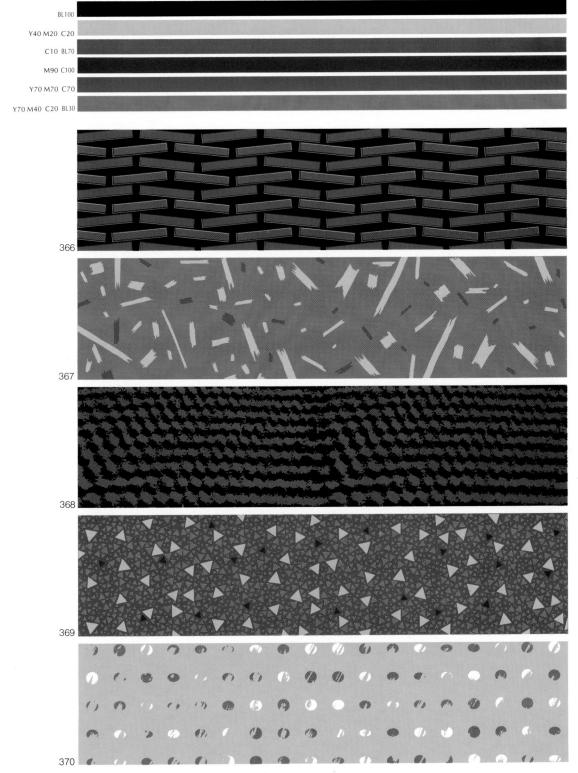

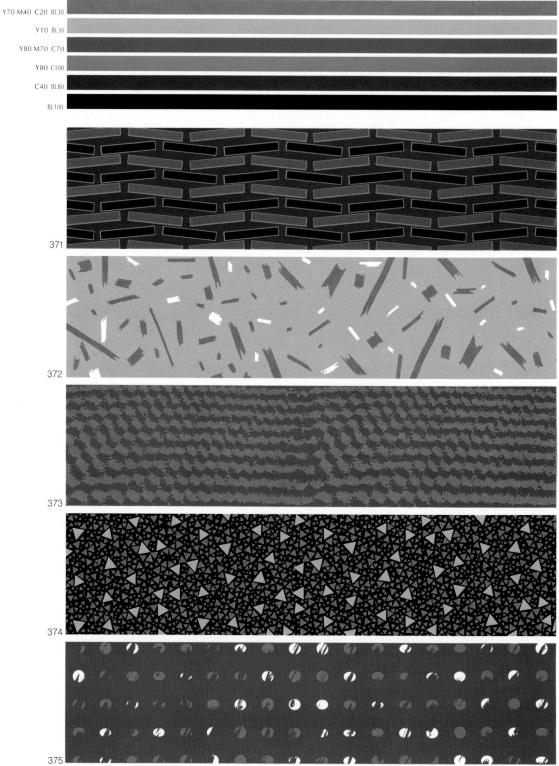

89

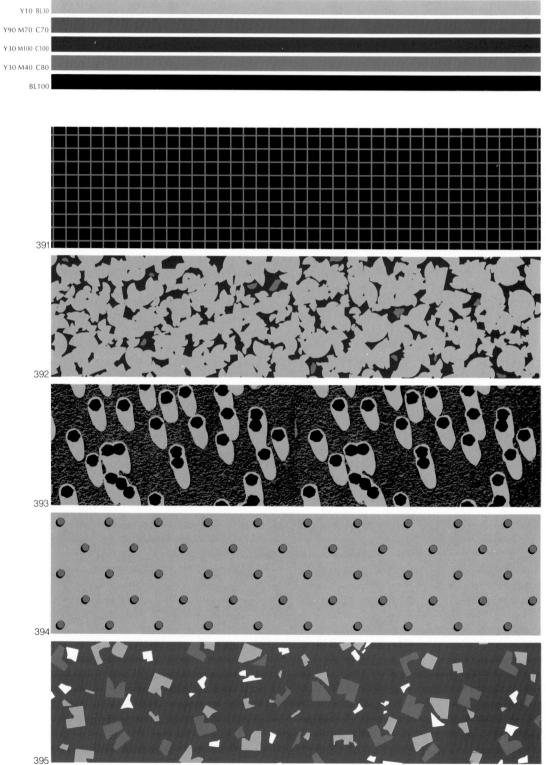

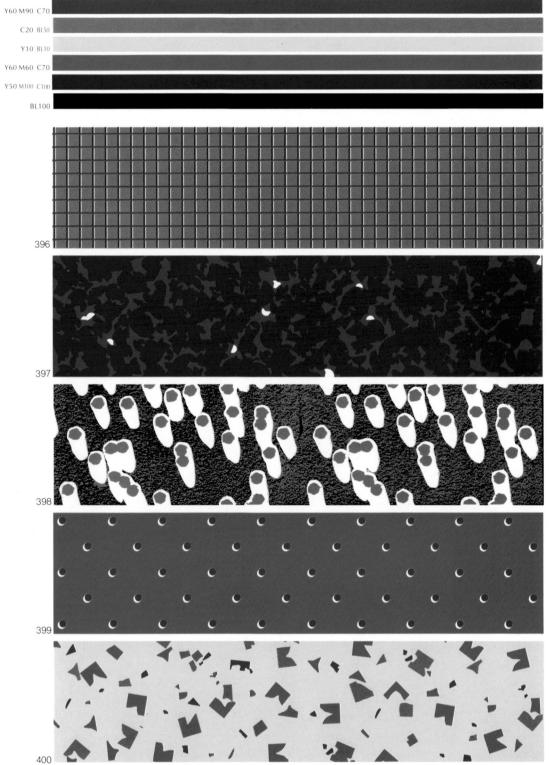

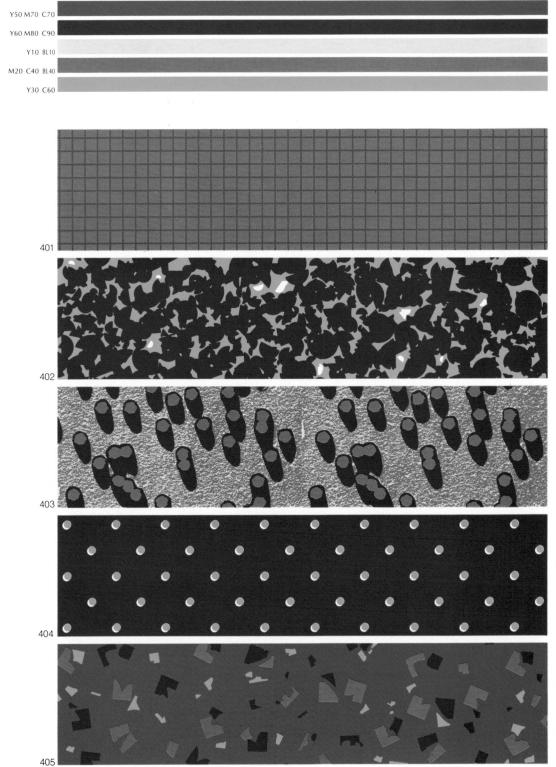

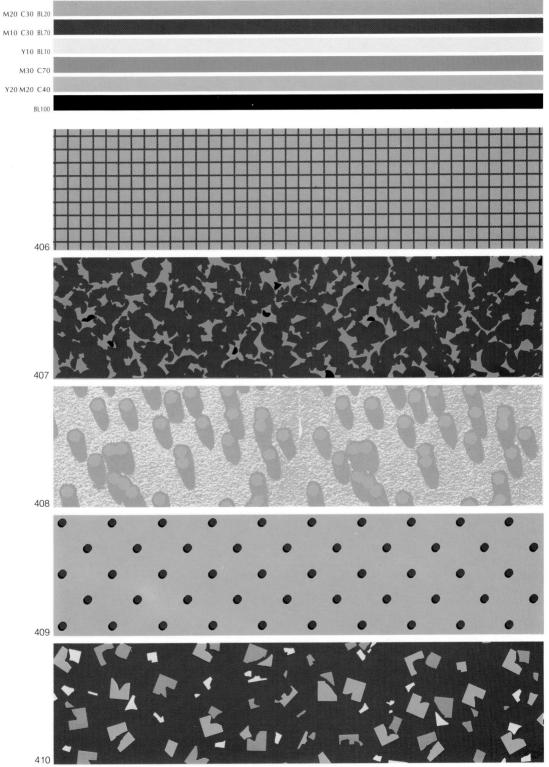

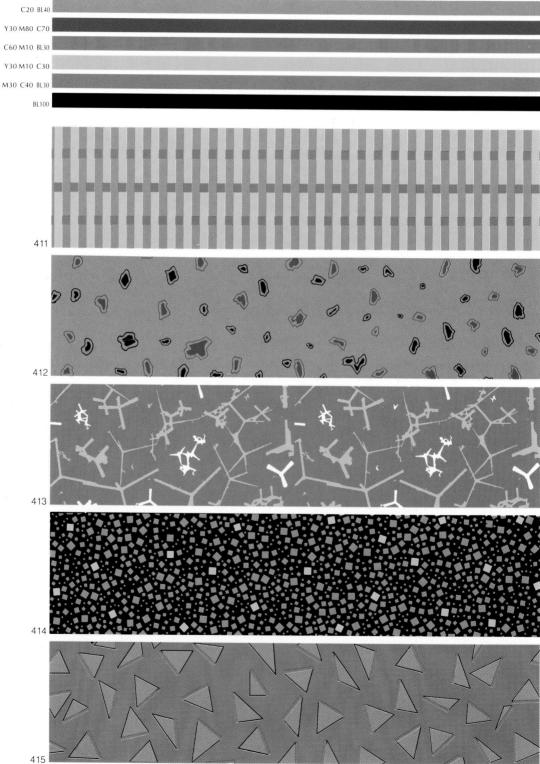

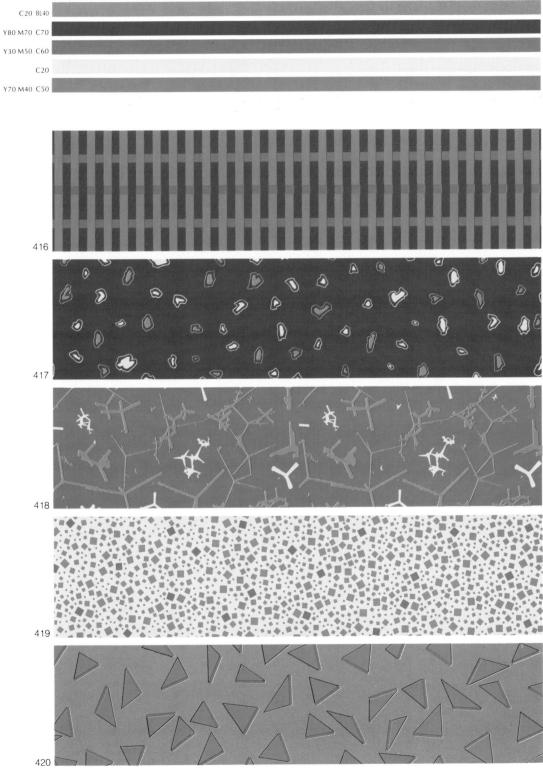

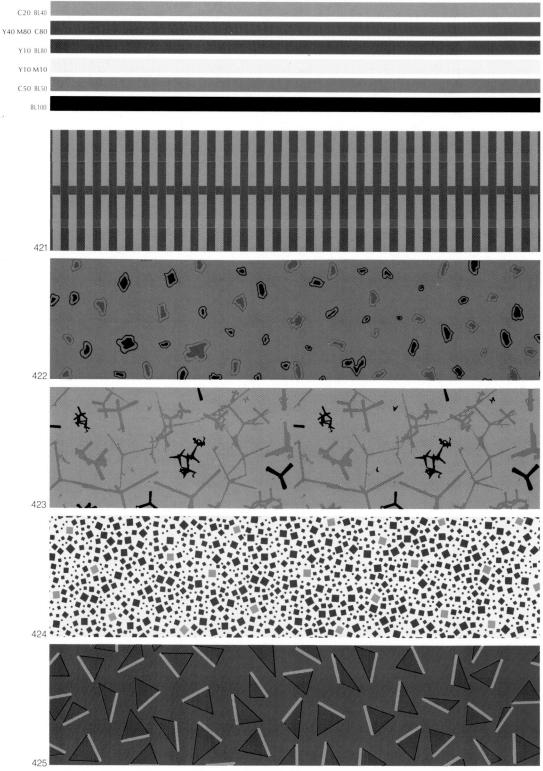

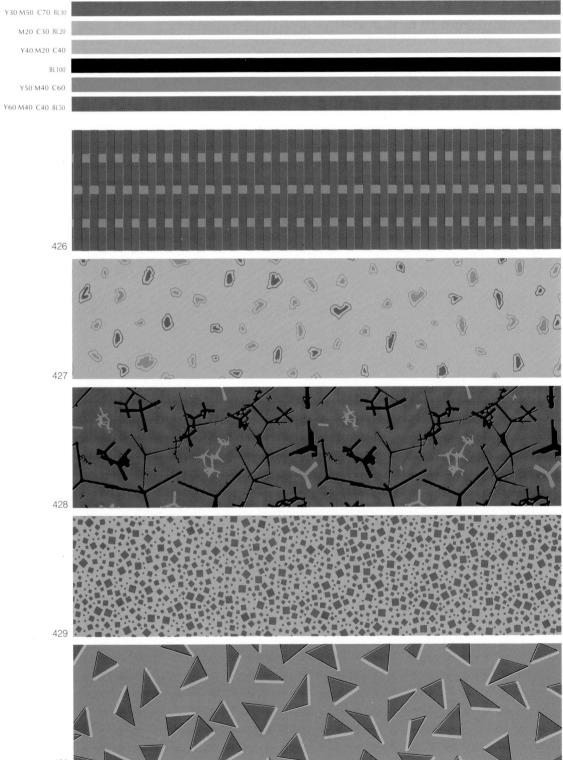

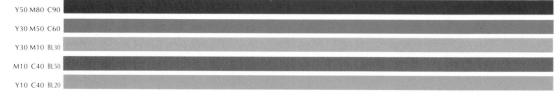

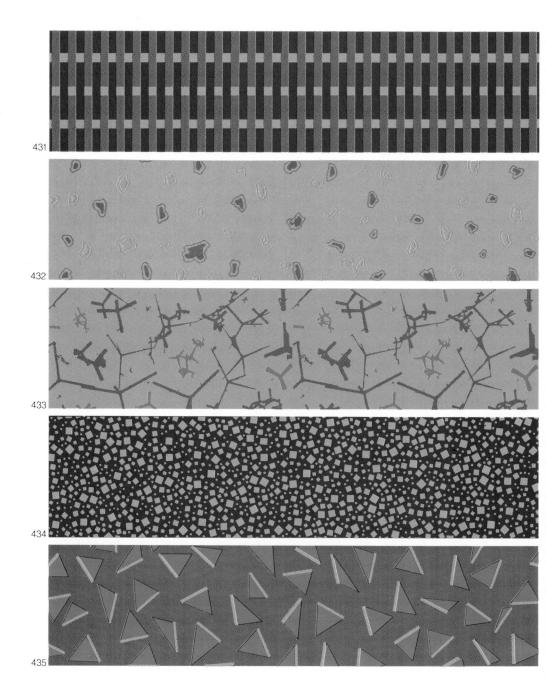

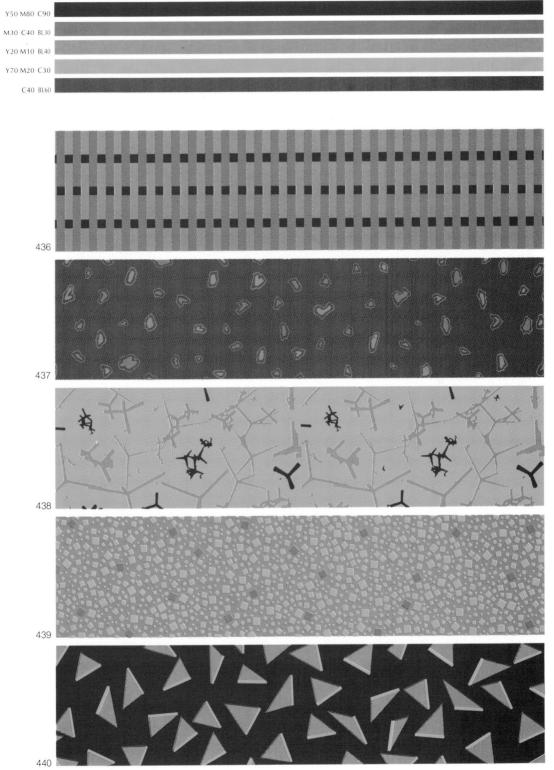

99

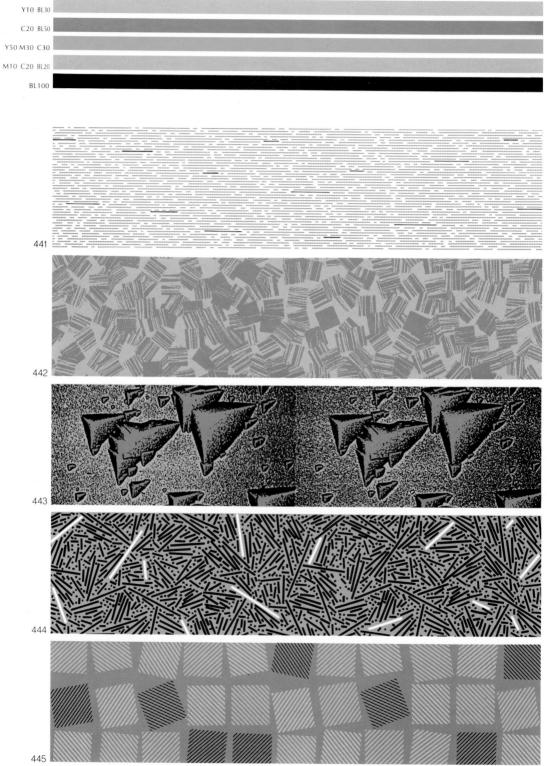

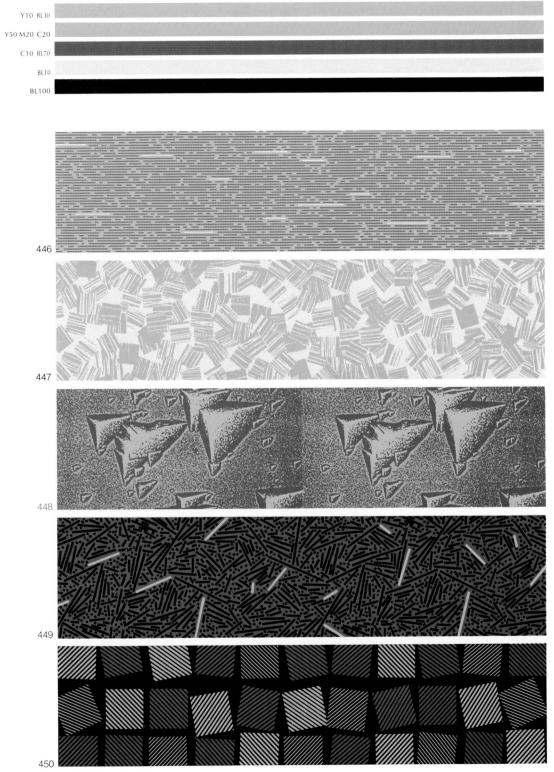

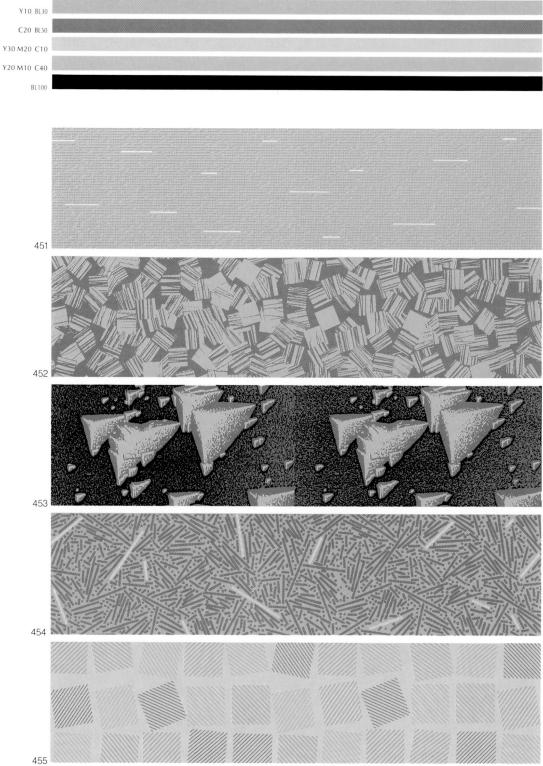

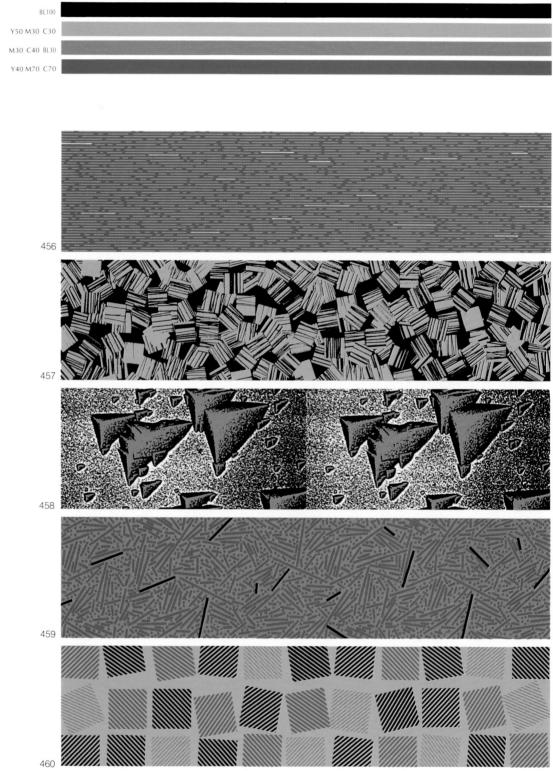

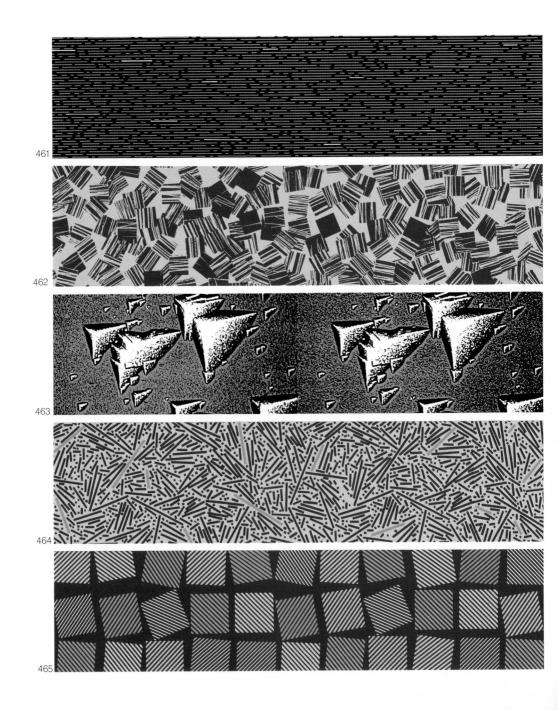

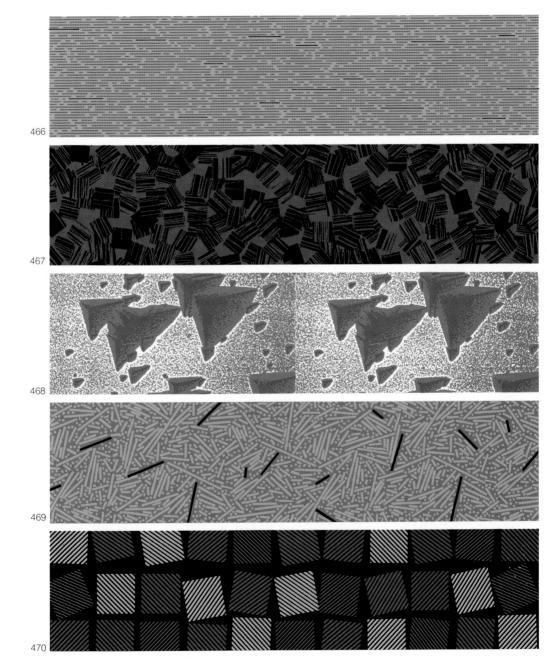

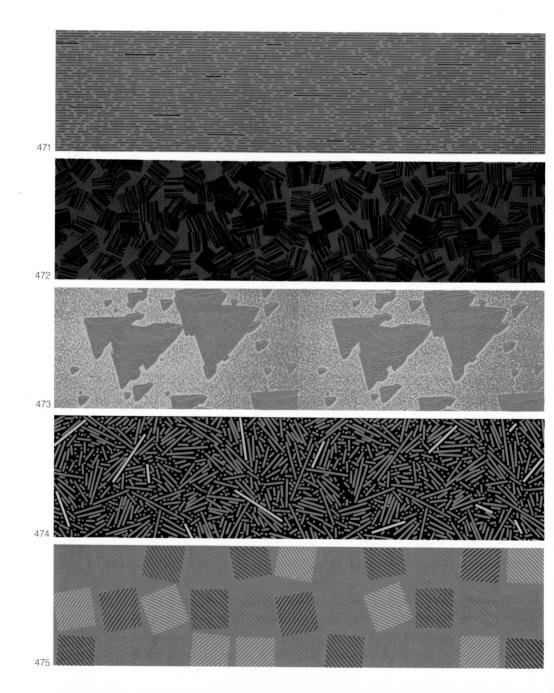

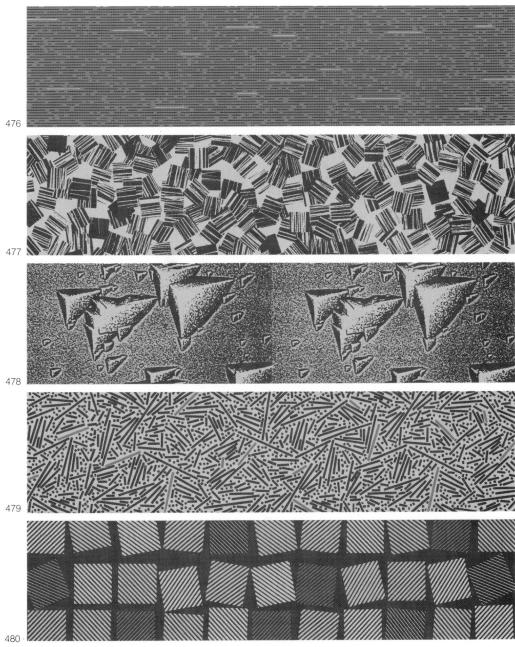

NOTES